For Nina ☺
May you always answer
the call of the wild!

Parks Reece
2006

CALL OF THE WILD

the art of
Parks Reece

RIVERBEND
PUBLISHING

For Charlie, my loving father
and a natural born rascal

Photographs of the artwork were taken by William Caldwell

Published by Riverbend Publishing, Helena, Montana

Printed in South Korea

1 2 3 4 5 6 7 8 9 0 SI 07 06 05 04 03 02

Cover and interior design by DD Dowden

ISBN 1-931832-07-2

Cataloging-in-Publication data is on file
at the Library of Congress

For more insight into the extraordinary art world of
Parks Reece we encourage you to check out his
website at: www.parksreece.com

Also visit the Parks Reece Gallery
119 South Main Street, Suite A3
Livingston, Montana 59047
Telephone: (406)-222-5724

To purchase prints, original limited edition
lithographs or original paintings that you have
enjoyed in this book, just contact or visit the
Parks Reece Gallery or visit our
website http://www.parksreece.com.
Shipping is no problem.
Some artwork may no longer be available.

RIVERBEND PUBLISHING
P.O. Box 5833
Helena, MT 59604
1-866-RVR-BEND (787-2363)
www.riverbendpublishing.com

RIVERBEND
PUBLISHING

ACKNOWLEDGMENTS

Thank you most of all, to my lovely wife Robin, who is not only the foundation of my art gallery, but actually built it, too. She makes the business side of art run smoothly, and allows me to paint and get away with looking organized. What a gem.

To Jan Myers, whose dedication and hard work in all aspects of my art production make her a precious asset and obviously a glutton for punishment.

To Tats Ogata, a great mother-in-law, for her ready assistance at all times, and for being such a good sport when I kid her unmercifully.

To Mickey Ogata, just for being such a great father-in-law.

To Dave Frederick, Nancy Nicholson, and Jody Ogata (a.k.a. Jodimus Maximus). If the devil is in the details, then these guys are exorcists.

To my son, Myers, who is a high school senior, nationally published poet, and award-winning play-wright and journalist, for leaving the girls alone long enough to write about Daddy and not even make him sound too bad.

To Tim Cahill and Scott McMillion, masters of their craft, who proved that a worthwhile endeavor is far more rewarding when accomplished with the kind of help that can only come from the best of friends. Proof also, that truly great writers work best when unencumbered by hair on their heads.

To my friend, Greg Keeler, for his insightful and witty sonnets, which share his broad understanding of nature, gained during a lifetime of skipping work to go fishing.

To my friend and companion Mike Haymans, a top-notch attorney, poet, singer/songwriter and commuter from the wild side, who wrestles alligators, bears, and the law.

To Edith Carter and Carolina Finley, for their patience and kindness in giving me childhood art lessons, especially since they usually had to chase me down and catch me first.

To my mother Gwyn Finley Reece and to my cousin Annie Winkler, where ever you are in the universe, for opening my eyes to the possibilities.

Finally, thanks to all the folks who have collected my art throughout the years, and to the various magazines and books that have reproduced it. You convinced us this book should be made, and my hearty thanks to Chris Cauble and Riverbend Publishing for making it happen.

"The most beautiful thing we can experience is the mysterious.

It is the source of all true art and science."

ALBERT EINSTEIN

PARKS AND THE ART

I'm staring out my window. A spring blizzard has just been sent packing by blue sky and a bright, warm sun. A few flies have begun to crawl across my view, activated by the rapidly heating glass. They're trying to solve one of the big mysteries of their lives: "If outside is just right there in front of me, and I can clearly see it, then why can't I go there?" The back yard is drifted in under wind driven billows of snow, which cover what had been brown winter grasses only yesterday. The temperature is rising toward sixty, and when the snow melts, the land will begin to green up all around.

by Parks Reece

I am reminded: what we can see of life is only at the surface, and there is always much more buried beneath. As I gaze, entranced, at the hot sun transforming the snowy world beyond my windowpane, I'm looking at all this white stuff and trying to decipher one of life's great puzzles. Well, maybe it isn't the actual Secret of Life Itself, but it's everywhere the eye can see and definitely on my mind. On my roof, too, for that matter.

That which is so close yet far away has always fascinated me. I feel a little like those flies on the windowpane, or—a less verminous comparison—a cat peering at a goldfish bowl. What is that shimmering panel that separates us from the Mystery?

We ride the earth, spinning at unimaginable speeds, while flying in a giant circle around the life-giving sun, and we don't fall off or even get dizzy. The light we see as

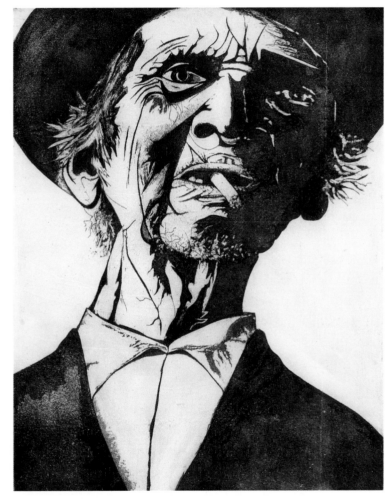

"Zat 'a monkey?"

Etching by Parks Reece, at age 19 while he was a student at East Carolina University

stars has traveled thousands of years to get to our eyes. Air, water, sunlight and love are free. It is good that our surroundings astound us. We wonder: Do wild animals have time for imagination? What's behind the amazing coincidences we sometimes experience? Where does the newborn baby come from? And where did that old person go who just passed away? And on and on and on. The unfathomable wonders that are routine in the workings of the world exist just beyond our view, like an unseen creature making noise in the night.

I am inspired by the notion of infinite possibilities and am utterly and passionately curious about wildlife and wild places (literally and figuratively). It is fair to say that my art is about these possibilities and this curiosity. Laughter is also high on the list of my life's priorities, so it stands to reason that fun is a central element in most of my pictures. I've been accused of using humor, wit, and social satire in the commission of fine art, and there is no doubt that I stand guilty as charged. But there are deeper layers, which the observant or curious viewer may find of interest. An artist who spends much of his time being mystified by the universe will be rewarded by an obscure law of nature, which states that through osmosis, deep secrets will be revealed in his art. Hey, would I kid you?

It would be fun to claim that I am an untutored artist, and that my peculiar brand of surrealism just happened one day, like a lightening bolt out of the blue. In fact, I admit that I studied with accomplished and nationally known artists before I ever attended kindergarten, and that my instinctive love of color and design led me to study at a couple of universities before earning a degree from the San Francisco Art Institute. That fine institution is not to blame for my style, however, for I have been honing it since preschool, and could perhaps

describe it as "refined caveman."

The trick, I think, is to combine the intuitive vision of a very young child with the drawing, composition and color skills of a highly trained artist. The vision isn't any good without the skills necessary to render it.

The process goes like this: with the mysteries of life swirling through my mind and all around the room, I take brush in hand. Now, the adventure begins. At first, while gaining altitude, the going may be slow. Eventually the mind yields and the universal flow guides the hand. Hours of work and problem solving slide by, seeming more like ecstatic minutes. Similar sessions continue for days, maybe weeks—the harder I work, the luckier I get. Then the alchemy happens: traces of the unfathomable are revealed and glimpses of what makes the noises in the night are on my canvas. What words cannot say, images do.

The art that results fills many functions. Often it can make us laugh out loud, snicker at ourselves and our relationships with nature, or it may prompt us to ask, "what do animals think," to ponder, or cuss, or see things as they are or are not. It fulfills a primary purpose of all fine art: It delights and thrills that piece of our brain that has been mesmerized by colors and shapes since humans began painting on cave walls.

It is afternoon now and the warm March sun has done its job well. From my chair by the window, I see the colors returning to my back yard. All around me, the Earth is drinking up the water that only a short time ago was an icy blanket covering everything. Birds fill the air with songs as they gladly emerge from the sheltering branches of evergreens. Yet the mystery that puzzles me still persists: Where, I wonder, does the white go when the snow melts?

POURING RAINBOWS OUT OF WINE GLASSES

The friends of Parks Reece tell Parks Reece stories. This is *by Tim Cahill* because his exploits are larger than life, often comically so, and because Parks himself is such a modestly easygoing gentleman that we, the friends of Parks, are likely to forget that we are dealing with a major talent, a man with a flair and faculty unique in American art.

One day it occurred to me that this was wrong. Someone ought to tell a Parks Reece story that was essentially about art. And so, over the space of a few days, I sat down with Parks and forced him to discuss his life and his art. The man speaks in a soft North Carolina accent. It is fair to say that he combines a southern gentleman's courtly charm with Bozo the Clown's concern for common sense and propriety. That's the public face. I also discovered a side of the artist that I didn't know, one that is more highly contemplative than I'd imagined. For instance:

I feel comfortable with the assertion that art is the central condition of Parks' life. It comes from someplace outside the person of Parks Reece and sometimes simply consumes him. Take, for instance, the matter of the providential chipmunk. Parks had been thinking about painting the creatures for some time. Tracing the concept is a difficult proposition that could get you trapped in the mind of Parks Reece. So it is best to simplify here: he had been thinking about the humorous exploits of the cartoon chipmunks of his youth, Chip and Dale. But that idea was clanging up against the name of a group of male strippers who called themselves the Chippendales, yes, so, and what if the Chippendales were actually Chip and Dale, which is to say, Parks had been considering the idea of painting dancing male chipmunks. Stripping.

Some research was in order. Now, Parks lives outside of Livingston, Montana, a town of some 7,000, on a south-facing hillside alive with rattlesnakes, a circumstance that probably limits the chipmunk population. There were a few red squirrels around, but no chipmunks. Parks went to the library, but the illustrations of the rodents in question were purely representational, and did not truly speak to the soul of Parks Reece. Besides, he needed them standing up on their hind legs, as if dancing, and there was a dismal lack of depictions of these creatures engaged in bipedal activities.

A person unfamiliar with the man's art might wonder why Parks couldn't just fake a couple of cartoony chipmunks. That, however, is not the way it is done. Parks draws his wildlife from the wild. His creatures are authentic, however odd or aberrant their behavior might be. Parks, a highly trained and talented artist, holds the currently revisionist opinion that painters ought to be able to draw. He himself has been refining his drafting skills literally all his life and he has always worked from nature observed.

"So," he told me, "I needed a chipmunk. I went up to Yellowstone and sort of hung around the picnic areas where I've seen chipmunks before." It was a wasted

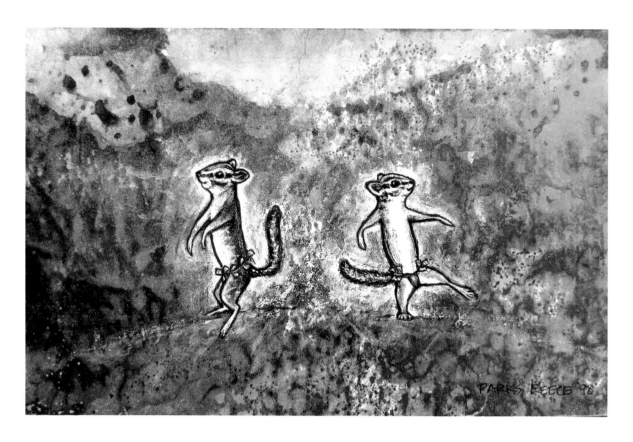

Chip 'n Dale Dancers

expedition. Yellowstone National Park, it seemed, was bereft of marauding chipmunks on that day. The painting was going nowhere. Art was not being served. Parks was despondent, or as despondent as he gets, which is to say, he was in a pretty good mood except that he was pissed off about chipmunks. The little bastards. Where were they?

Now the plot thickens, because here enters the mystery chipmunk, the entirely providential rodent, the bipedal artist's model strolling out of some incomprehensible realm occupied, Parks believes, by the objects and intentions and splendor of art itself.

"I was working in my studio downstairs," he told me. I knew the place. There is a long horizontal window looking out onto the mountainside to the south. Parks was standing at the window, in a place where he almost never works. And there, directly in front of him, just on the other side of the pane, was a chipmunk. But this wasn't just any chipmunk. This was the chipmunk of his waking

dreams, the rodent of wonder, the creature creative. "Because," Parks said, "it was standing up on its hind legs, looking in the window." Front paws on the pane, the animal moved back and forth.

"So," I said, "it was dancing."

"Yes sir," Parks said. "And he was there for maybe ten minutes while I sketched him. I mean, I've lived in that house for fifteen years and I've never seen a chipmunk. I haven't seen one since."

The man for whom the chipmunks dance was born in January of 1954, in Wilkesboro, North Carolina. He grew up in the foothills of the Blue Ridge Mountains, where all these layered mountains, wispy with fog, rolled away off to the west. Art was the condition of infancy. His mother, Gwyn Reece, was one of the few practitioners of finger painting as high art, at least in the late 50s and early 60s. She worked with the first of the high art finger painters, Ruth Faison Shaw, who literally invented the medium,

initially as therapy for shell-shocked veterans. The two women had critically acclaimed shows in New York and Los Angeles. Parks learned to paint—with his fingers, and under the tutelage of the two great artists—before he could talk.

"Some of my first memories," Parks told me, "are of finger painting. I have a piece I did when I was three. Mom framed it." Parks didn't recall painting the picture, but "when I look at it today, I recall that I was trying to paint a dream. The painting looks pretty abstract but I remember I had dreamt a glass, like a wine glass, and a rainbow coming out of the sky coming down and filling the glass. There was no story line to the dream that I recall. It was just a scene."

When Parks was six, he had his first show. "It was with Mom and Ruth. I actually sold some pieces. Made $110. Which is a lot for a six-year-old."

"My mom," Parks told me, "saw ghosts and believed she could sometimes see behind the veil. We used to go out at night, in the car and sit on these lonely back roads in the places where Indian spirits were supposed to cross. I was probably seven or eight and thought it was kind of exciting. Like a police stakeout or something. I never saw any ghosts. Didn't see 'em in Cape Cod either. One summer we stayed there, in Ruth Shaw's ancient Victorian house. It was ghost central. There were noises at night, and we'd find stuff moved around a little in the morning. Mom said she saw three ghosts and she knew them by name."

Parks is rarely contemplative, which doesn't mean he can't be thoughtful, and he believes that what he learned ghost watching with his mother "is that there is more going on than we know about."

"But," I asked, "you never saw any ghosts. Never had any supernatural experiences...."

"Did I tell you about the chipmunk?"

"Yes. But that could be coincidence."

"Okay. Here. One night my mother woke up screaming. 'Ruth died,' she screamed. Well, Ruth Shaw

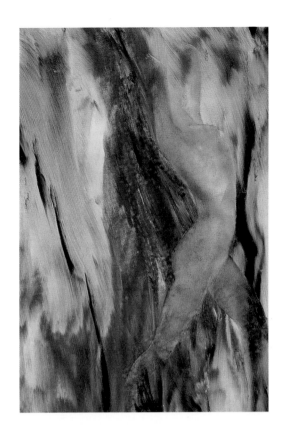

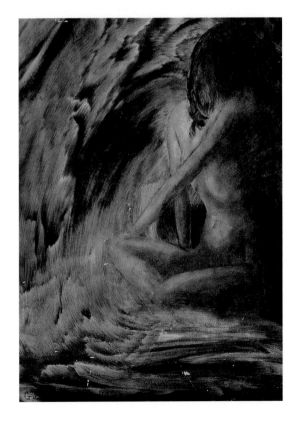

Untitled finger paintings by Gwyn Finley Reece

(left)
Red: 21 x 14, 1961

(below)
Yellow: 20 x 15, 1961

5

was 250 miles away. The next morning we got the call. Ruth had died in the night."

"So you believe in the supernatural stuff?"

"I just think that there are layers and layers of things, and you can peel them back with a sense of wonderment. There's more than we know. That's all I can say for sure."

Back when Parks was a boy, the Reece's had a house about four miles out of Wilkesboro. Parks spent a lot of time by himself, alone in the woods, just looking at things. His father, the courtly Charlie Reece, traveled a lot on business. His mother, who died when Parks was 19, was often sick. "Mom and dad loved me," Parks said. "It's just that I didn't have a lot supervision growing up. I spent an awful lot of time out in the woods. There weren't many other kids living nearby, so mostly I was alone. I looked at things and I guess I was thinking about peeling back the layers, even then."

That was his early life in a nutshell: a strange amalgam of art, nature and the supernatural. His boyhood, Parks thinks, "left me with idiosyncratic ways of thinking about the world and art." It is always a surprise when words like "idiosyncratic" spill out of Parks Reece's mouth.

In school Parks was the class artist. He did the posters for all the events, but he wasn't just a poster wonk. Parks is something of a natural athlete. He is gifted with speed, surprising strength for his size, and effortless coordination. He learned karate, competed in track, and golf, but he was best at football, where he played sixty minutes: a safety on defense, wingback on offense.

After graduation, Parks Reece careened around the continent for a time. "I went to East Carolina University," he said. "They had a good art school and were very strong on fundamentals, on color and design and drawing." A year or so later, Parks was in Costa Rica, where he went to study Pan American art history. He sat in the town square and drew portraits of folks for two bucks apiece. Meanwhile, he was living in a dirt-floored cabin with some Mosquito Indians, refugees from Nicaragua. "They

had a white dog," Parks said. "I painted black stripes on him so he looked like a zebra."

"What did the Indians do?"

"They looked at me," Parks said. "Kind of strangely, I guess."

This is not an unusual reaction to a Parks Reece stunt, even today.

Meanwhile, Parks had applied to the San Francisco Art Institute, and, during the time he was painting dogs to look like zebras, he was accepted to study at that prestigious institution. "I worked hard there," Parks said. "I majored in print making. All great artists have tried their hand at prints. I wanted to learn prints to round myself out. I figured I could teach myself to paint."

At the time, Minimalism was big: a single black square painted on white canvas. That sort of thing. "I thought the Minimalists had tapped into the big...the big...oh what's the word I want. Just call it 'The Big.' But there was too little discipline. Too little regard for the fundamentals."

Parks struggled to make his point and then wrestled it to the ground. "You need to be strong in composition and design and color and drawing. You never know when you are going to tap into...the Big...and you really need to have all your tools at hand when you do."

After graduation, Parks used his degree from the nationally celebrated Art Institute to secure a job as a bicycle messenger, where he raced the wrong way down one way streets, pursued by cops. He thought about getting a job in the merchant marine, but a fellow student at the Art Institute, a wealthy woman in her 60s, offered him a job at a ranch in Bighorn, Wyoming. Parks was the resident artist and cowhand. For two summers, he milked cows, fixed fence, irrigated and painted pictures. There was also time for him to do a couple of murals, one in The Professional Building in downtown Sheridan, Wyoming. The mural has since been moved.

In 1977, Parks spent a month teaching art on the Crow Reservation in Montana. It was a good experience, and

Parks thought he might teach for a living. He attended Montana State University, got his teaching certificate, and did his student teaching in Great Britain, in County Clwyd, Wales, at the Elved school. "Reece," Parks said, "is a Welch name. We come from a coal mining background." Still, Parks was just slightly out of place at the Elved school. "I dressed like a hippie, but I noticed everyone else, even the students, wore coats and ties." The fact that Parks noticed this did not motivate him to dress more formally. "Then," Parks said, "I came into school one day, and there, on my desk, was a folded up suit and tie."

"What did you make of that," I asked.

"I figured they wanted me to wear it."

"Did you."

"Yes sir," Parks said. "I surely did."

Once back in the United States, after six months in Wales and a bicycle tour across Europe, Parks spent some aimless time driving back and forth across the country in a succession of beater cars, all of them breaking down in various inconvenient towns. He worked in the construction and the firewood collection business and was also a landscaper, log peeler, concrete finisher, sod cutter, substitute teacher, junkyard worker, and a mill stone dresser, which, Parks says, "is kind of a lost art." Eventually, he found himself in Gardiner, Montana. "It was the fall of '78," Parks said. "I didn't have much money, so I hunted and fished for food. The winter that year was notoriously severe. I mean, a twenty-below-zero blizzard is a whole 'nother world. It's like being underwater. It struck me as an adventure."

And, indeed, Parks has never left Montana. By his lights, he leads a life of adventure. At this time, he scored a job in Livingston as the Curator and Director of the Danforth Gallery, a non-profit art center administered by the Livingston Friends of the Arts. Livingston is sixty miles away from Gardiner, so Parks, who did not own a car, hitchhiked back and forth, every day. Eventually, he bought a 1969 Nash Rambler Rebel, which he decorated with perforations produced by a .22-caliber rifle. He may have been producing art with bullets, trying to find a connection to The Big, but it is my contention that Parks has always had adversarial relationships with automobiles and he was punishing the blameless Nash for the sins of cars long since trashed.

The Danforth Gallery board encouraged Parks to attend a Montana Art Directors' lunch meeting with then governor, Ted Schwinden. Parks—no one who knows him would find this remarkable—somehow got his signals crossed and arrived an hour late for the lunch. He pulled up to the governor's mansion in his bullet-pocked Rambler, and was, not surprisingly, questioned rigorously by the security staff. He ended up not only meeting the governor, but chatting with him, privately, for over an hour, about the state of the Arts in Montana. The governor personally fixed lunch for the Livingston artist.

This is typical of most Parks Reece stories: things almost always work out for the best, except when they don't, and then, generally, there's a laugh at the end.

Parks never sold his own art at Danforth Gallery shows. He felt it would be, somehow, unethical. To supplement his income, he did commercial art—signs, promotions, posters, book illustrations—and with no regrets. "I always figured, hey, if it's art, I can do it."

All the while, he was perfecting one of his unique procedures. Parks finds inspiration in incident, if not to say actual accident. Even today, down in his studio, where the chipmunk dances, there is a drawer full of heavy-duty drawing paper smeared with accumulations of oil-based paint. These abstractions have been used to wipe paint off a sheet of glass after a print run. Most printmakers toss them. They're trash. But colors and shapes appear on these sheets. Parks always sees something in the various combinations of swirling tornadoes or of hushed insensible serenities. To him it is not trash, it is "free art."

Some of these sheets were first smeared twenty years ago, and Parks is likely to have used each one dozens of

times. Every once in a while, he takes out a few, and figuratively tries to peel back the layers. "It is completely abstract," Parks admits, but sometimes he sees things that might strengthen an image he has in mind. Sometimes the patterns and colors may coalesce into the under-image of a new painting.

Parks will then begin painting on the cleanup sheets, modifying colors and designs, so that the foreground figures cavort about on a carnival of chaotic colors. People liked the combination of abstraction and discipline, though few were likely to phrase it that way. They just bought Parks Reece paintings. Everybody I knew had to have a few.

After the Danforth, Parks set up his studio in a room on the top floor of the Murray Hotel in downtown Livingston. He was the Murray's officially designated "resident artist," a sort of artsy tourist attraction. Things were, quite suddenly, hopping in town. Some big-name writers had lived there for years, along with a variety of well-known actors. People were shooting movies in Livingston. "I guess it was sheer luck," Parks said. "I found myself in the center of this interesting place full of interesting people."

The most interesting was a woman named Robin Ogata. Parks met her while he was still at the Danforth. She has a flair for numbers and for organization, skills that Parks notably lacks. There were some other attractions as well. Parks married Robin and, in the fullness of time, say a couple of years, Parks' talent combined with Robin's business acumen, resulted in financial success. "I've made my living selling my own art ever since," Parks said. .

In 1984, Robin and Parks had a son, Myers. The day before Parks and I sat down to discuss his career, Myers had played one of his best high school basketball games, scoring twenty-one points and sinking a three pointer to win at the buzzer. "I don't like to boast on my own son," Parks said, and proceeded to boast on Myers for fifteen minutes. Eventually the conversation drifted back to art.

Parks opened what he calls "my Reece-only gallery"

in 1992, but he had his first "Reece-only Danforth show" in 1985. Parks said, "The Danforth used to be The Antlers Bar. All these drunks kept stumbling in, looking around at my work on the walls."

"What did they say," I asked.

"Mostly they just asked, 'why?'"

"Seems," I said, "like a good question."

Parks thought about it for a minute. "There's a sensation I get when I'm painting," he said. "Consciously, I don't know what it is. But its like things happen of their own volition. Stuff zips down out of the ether." He paused again, thinking, working on these concepts. "There's a euphoria. Really, it's almost a physical sensation. I mean, you have to have the skills and have a lot of experience with color and composition and design and drawing: all that has to be almost automatic. But then you can tap into the big, uh...."

"You were calling it 'The Big' earlier," I said.

"I just don't want to get too heavy about all this," Parks said.

"Is that why you use humor in your art?"

Parks thought for a minute. "Yes sir," he said. "That's one reason."

"The Big," I prompted.

Parks said, "It's a kind of flow. I think people who do meditation might feel it. I mean, I can paint, and, if it is going well, six hours can go by. Seems like six minutes." He paused again. A minute went by. It seemed like five. "I'm not really comfortable talking about this," Parks said finally.

I thought of the little boy wandering the North Carolina woods, with layers of misty mountains rolling off into the distance; the kid whose mother saw ghosts; the child who was exposed to the technical elements of art as a toddler. Here, I thought, is an artist who has never lost his child-like sense of wonder. He is still pouring rainbows out of wine glasses. The natural world constantly surprises and delights him just as he constantly surprises and delights us.

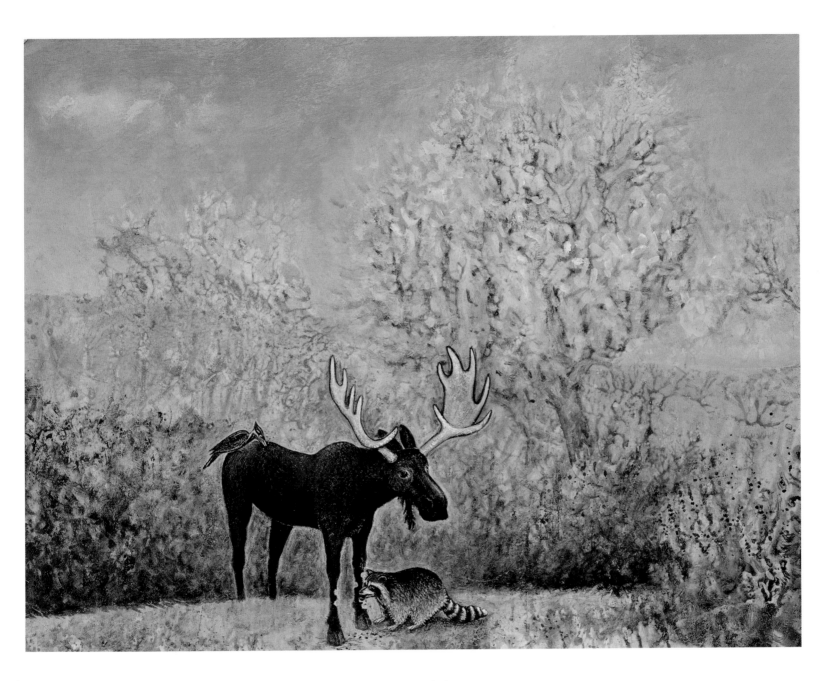

CHOCOLATE MOUSSE

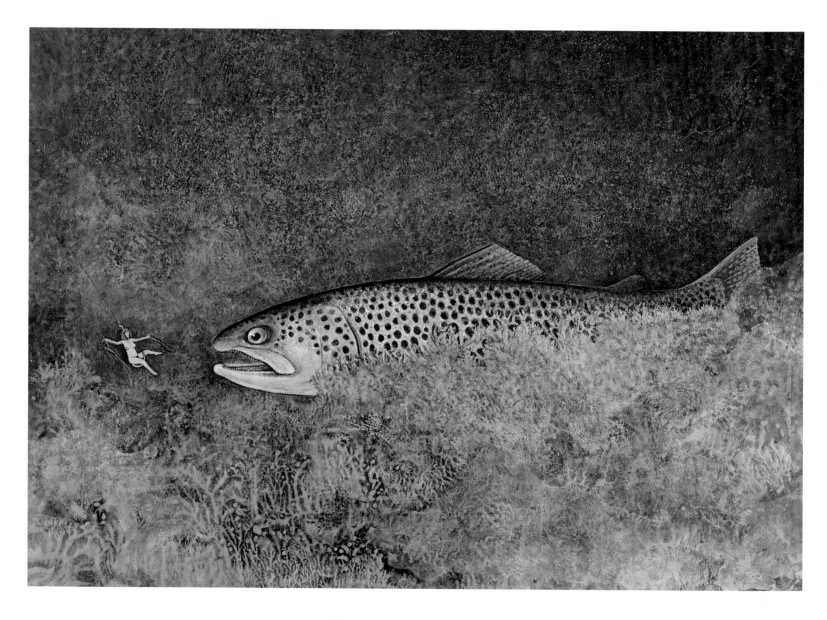

ADVANCED NYMPHING

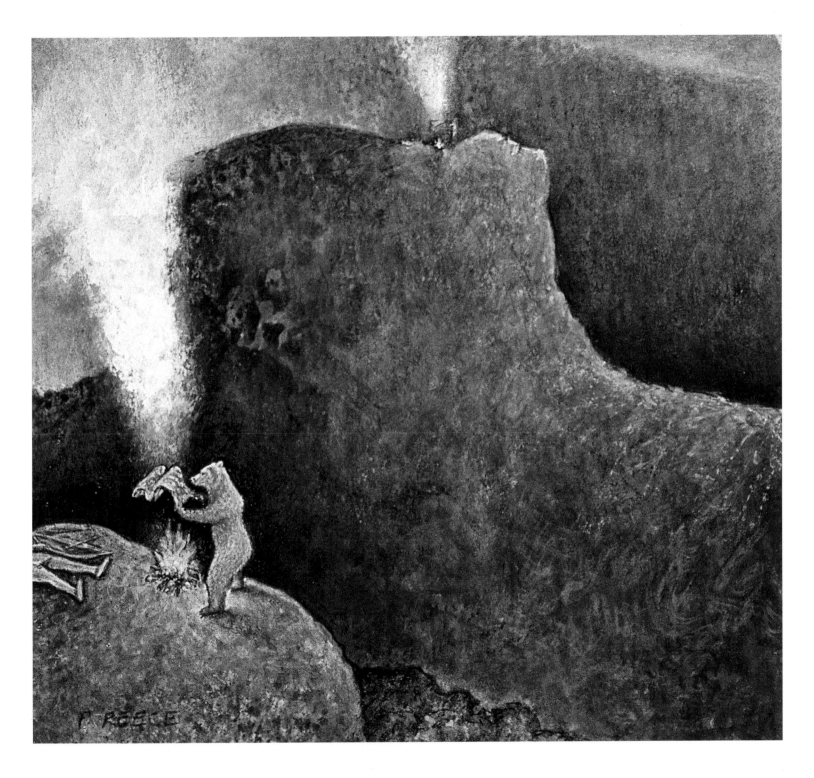

SEND MORE INDIANS

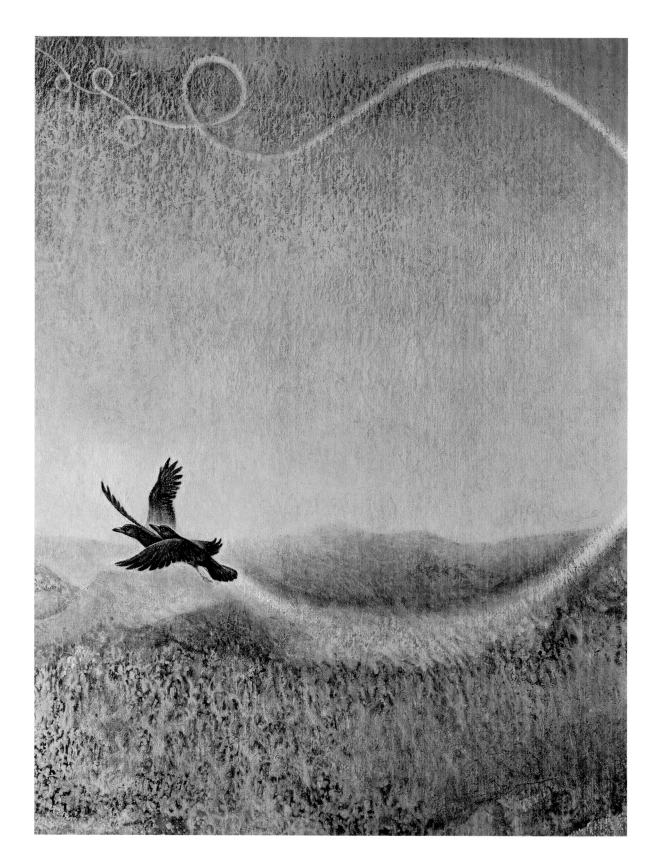

HOT CROWMANCE

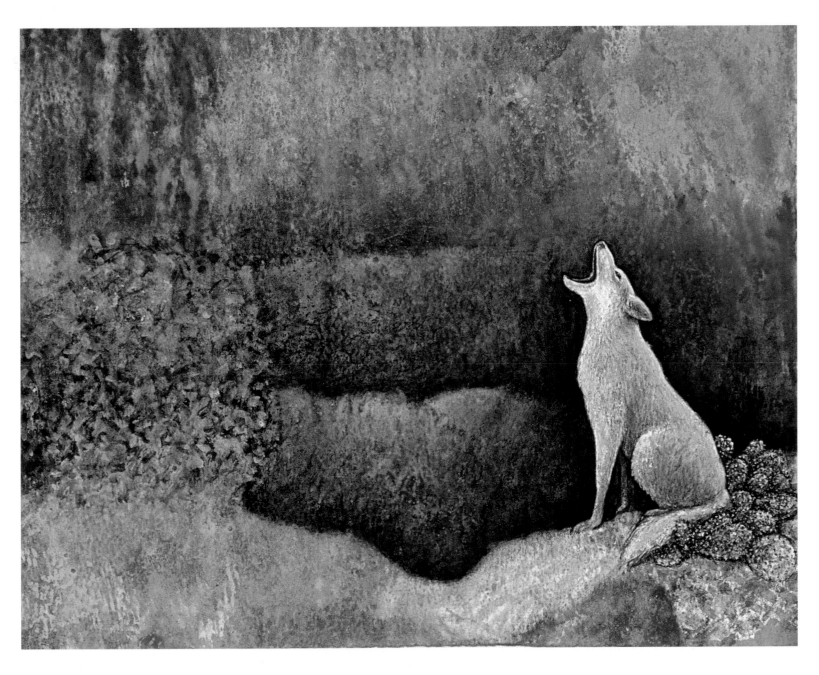

WHY THE COYOTE HOWLED

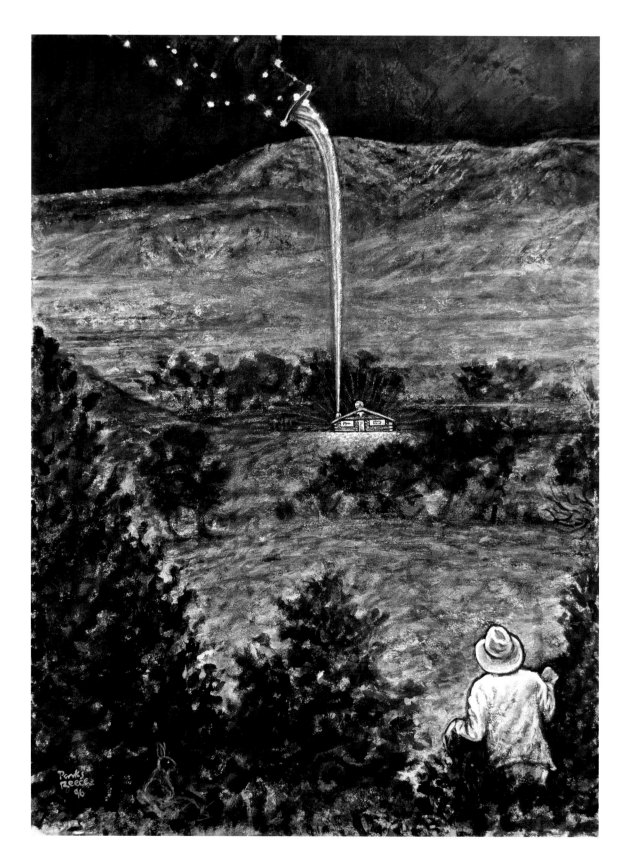

MONTANA
WATERING HOLE

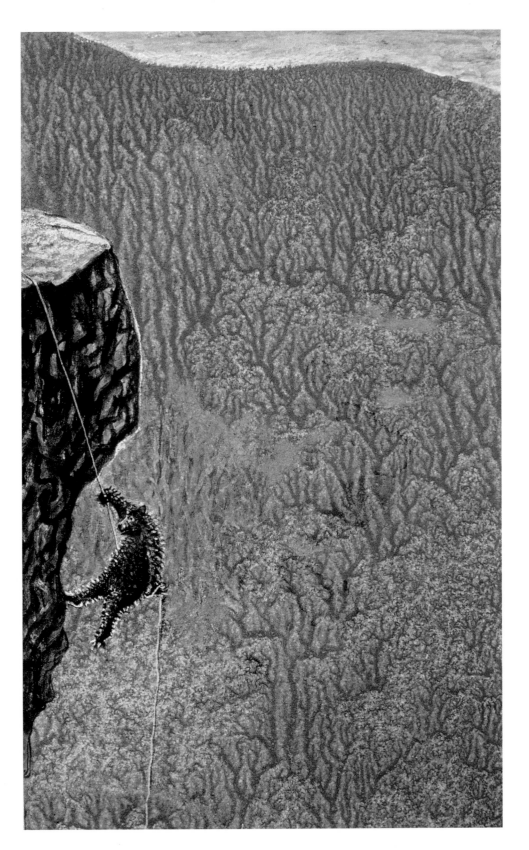

BEAR RAPPELLENT

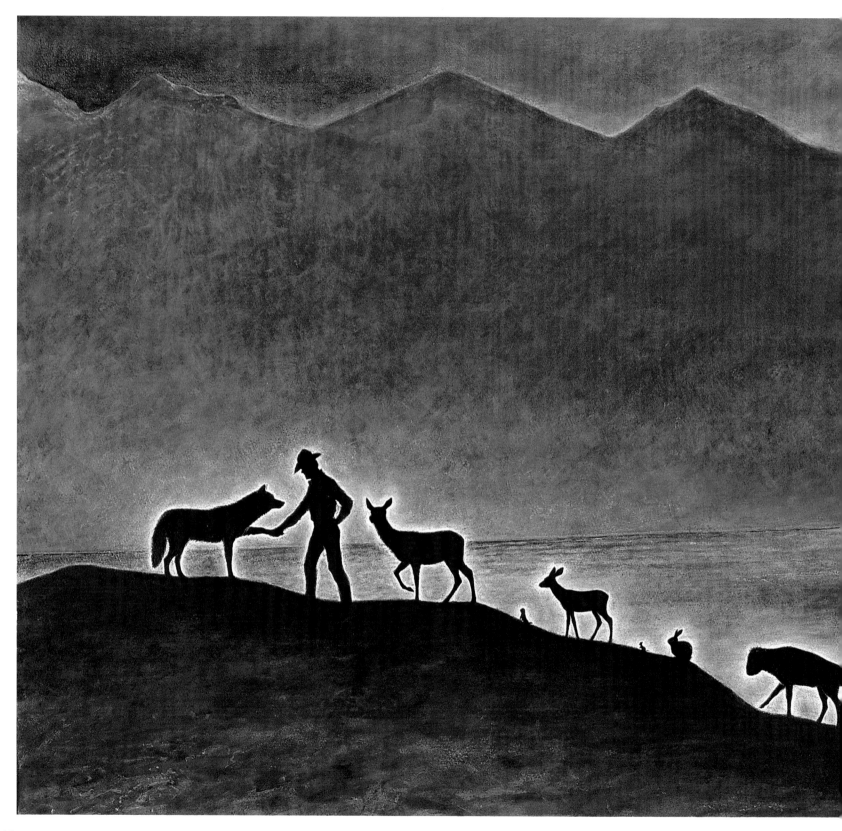

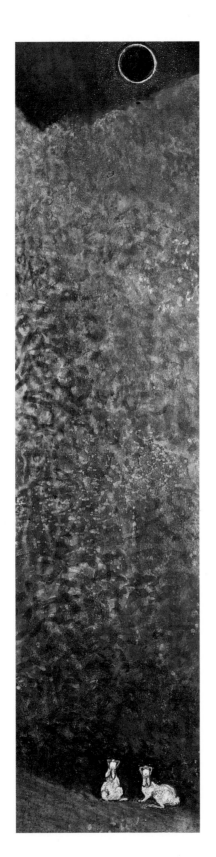

ECLIPSE

RE-INTRODUCING THE WOLF IN YELLOWSTONE

(FAR LEFT)

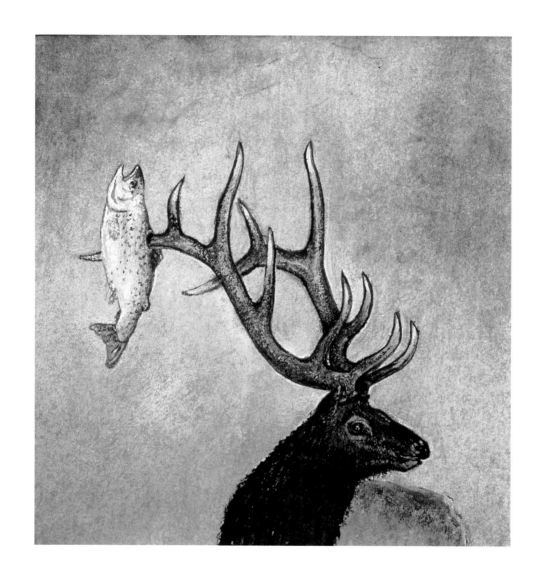

FISHING THE ROCKIES

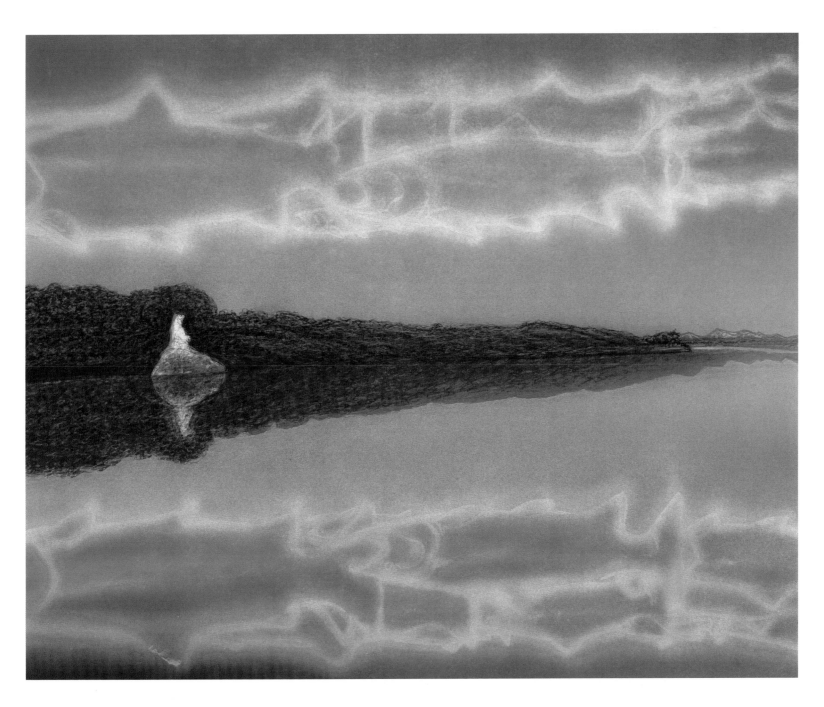

THE WISHFUL THINKER

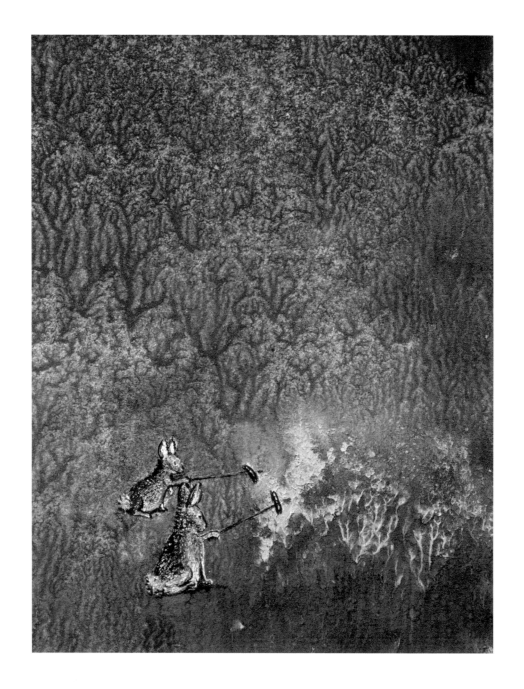

AFTER THE FOREST FIRE

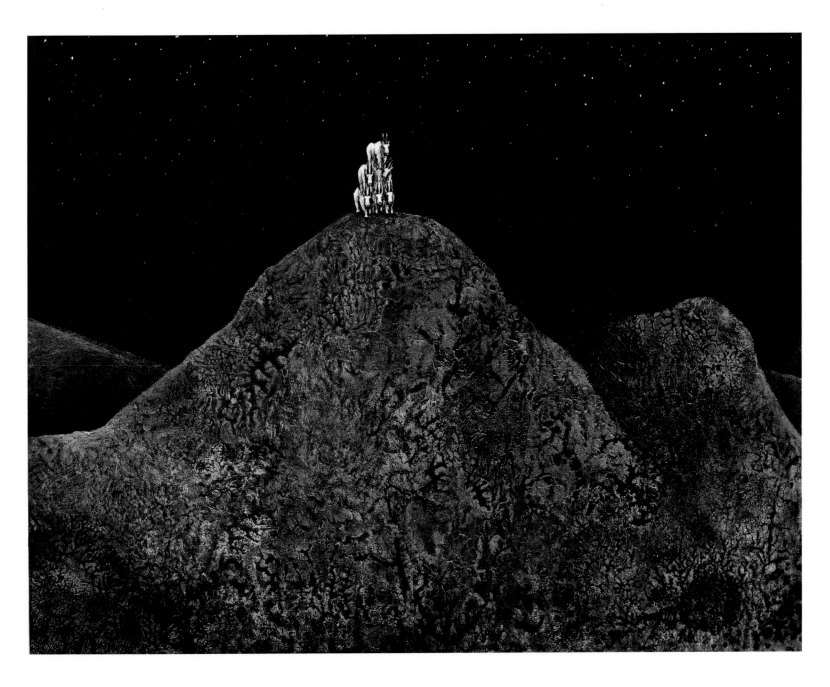

THERE'S ONE ON EVERY CROWD

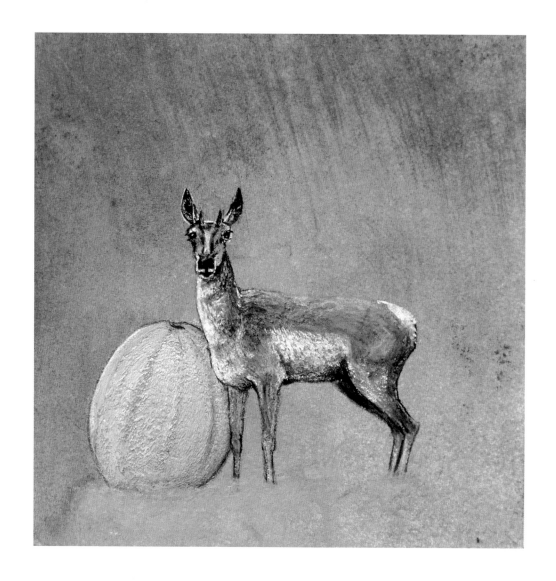

A Chance Encounter

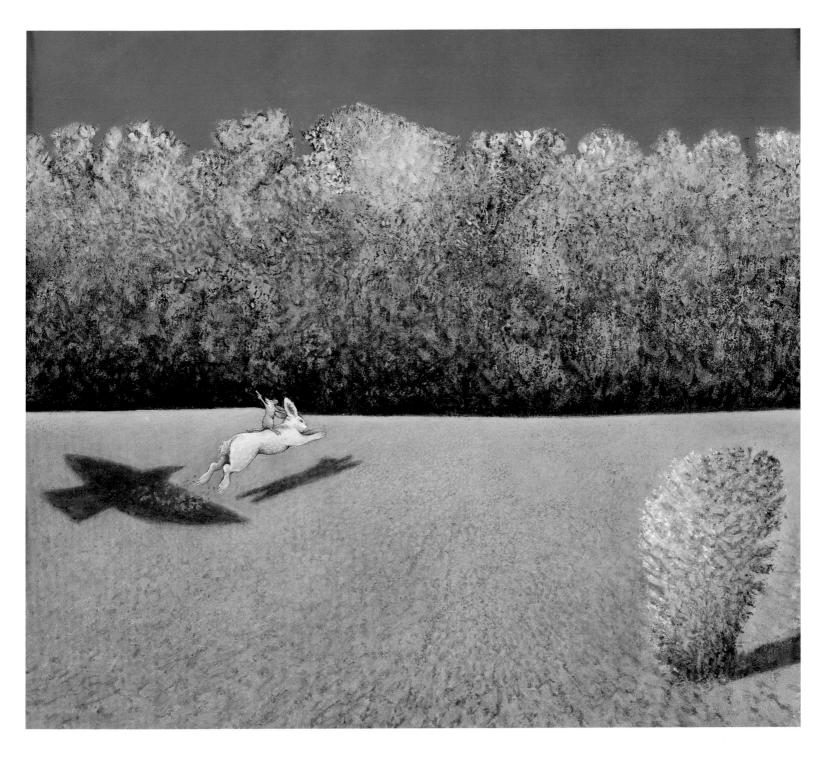

BEYOND THE SHADOW OF A DOUBT

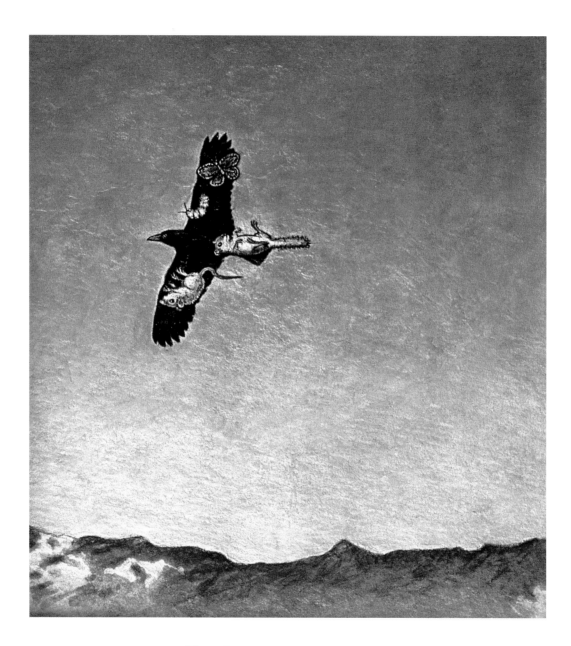

THE LEGEND OF VELCROW

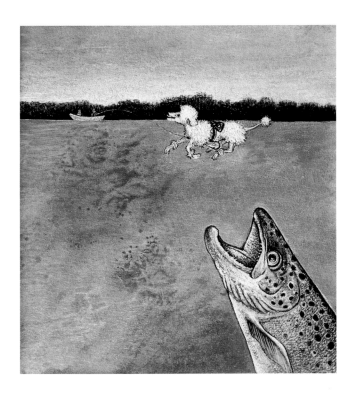

THE AMAZING FRENCH LURE

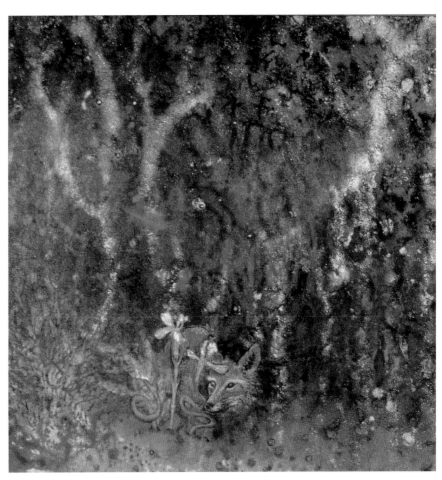

FOX IN THE PHLOX

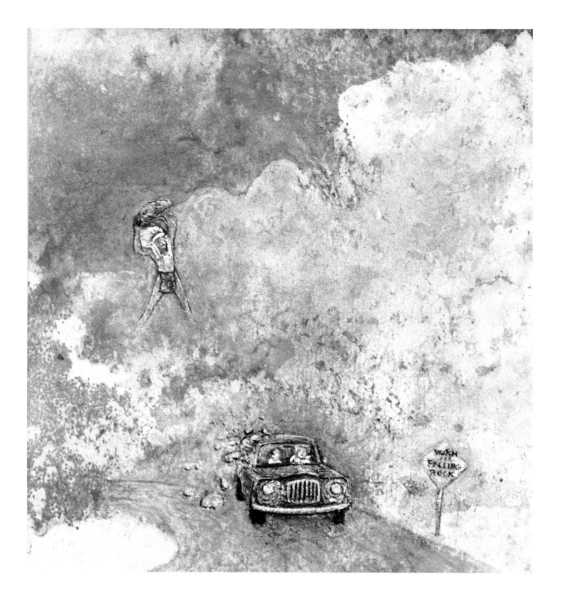

A Childhood Myth

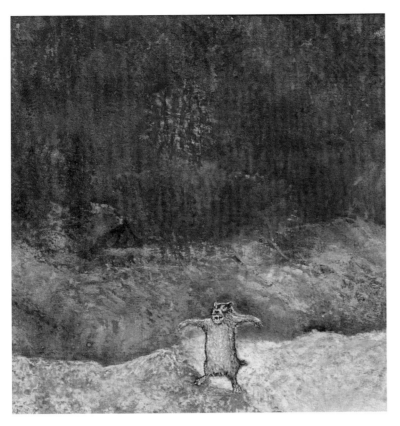

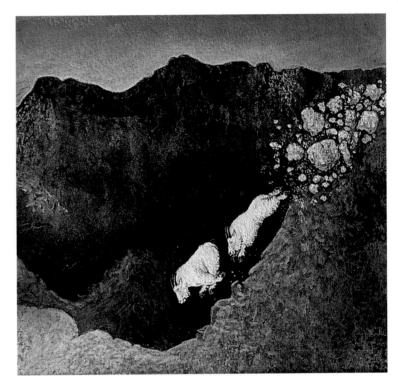

OCCUPATIONAL HAZARD

GROUNDHOG'S REVENGE

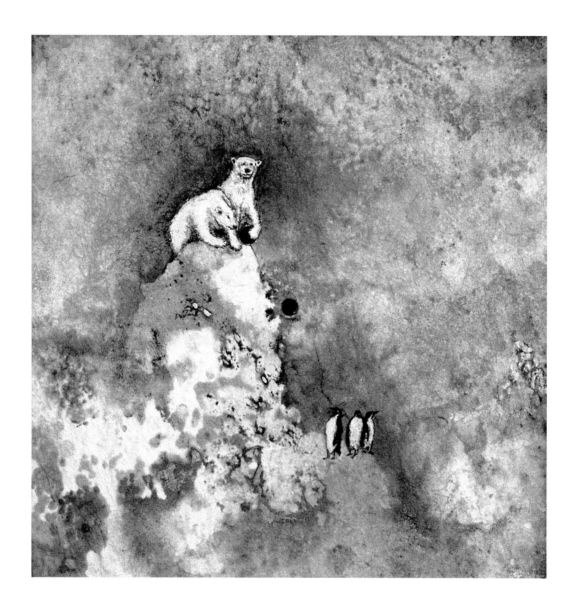

BOWLER PAIR

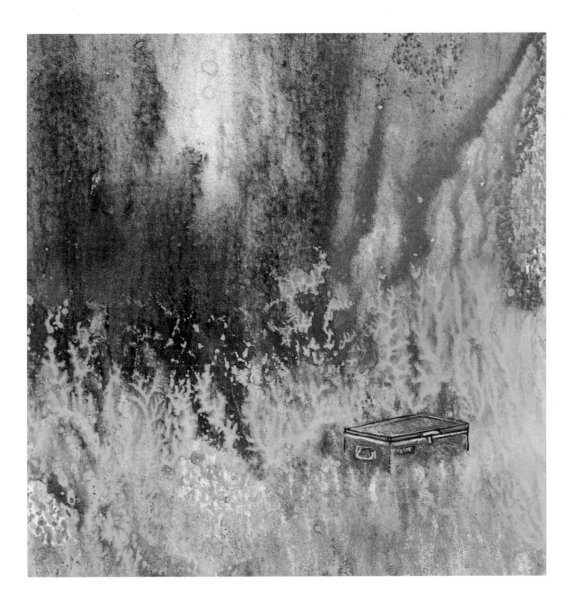

A Snowball's Chance in Hell

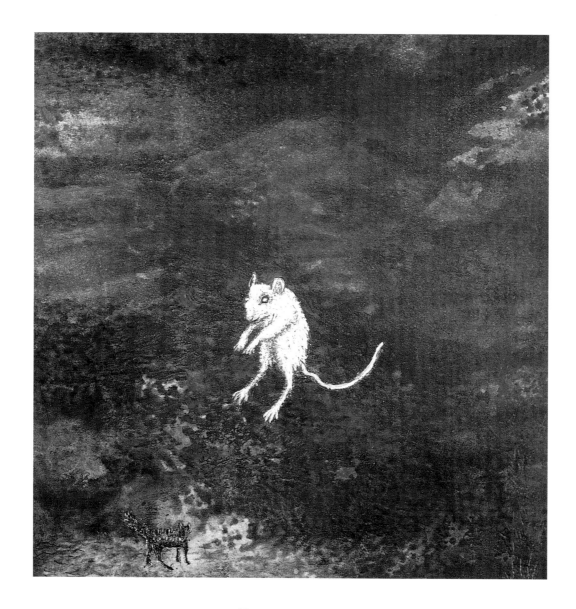

POLTERMEIST

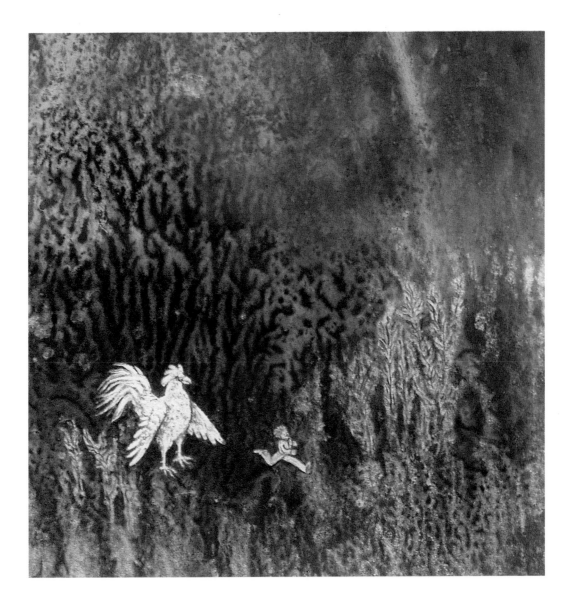

POULTRYGEIST

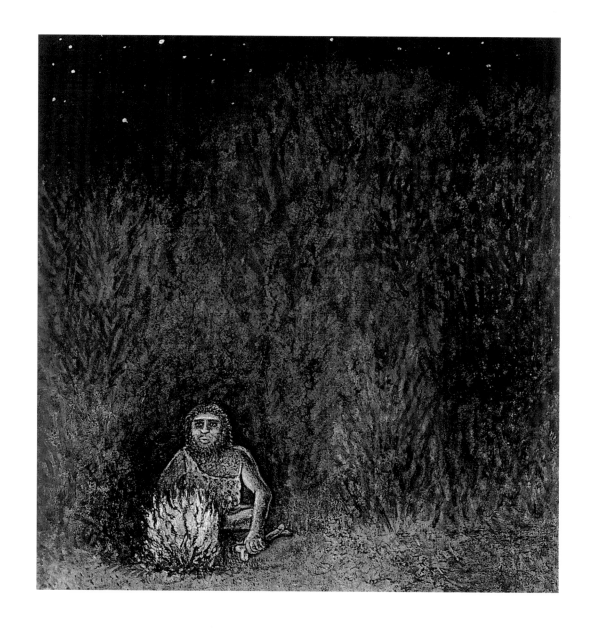

NEOLITHIC TELEVISION

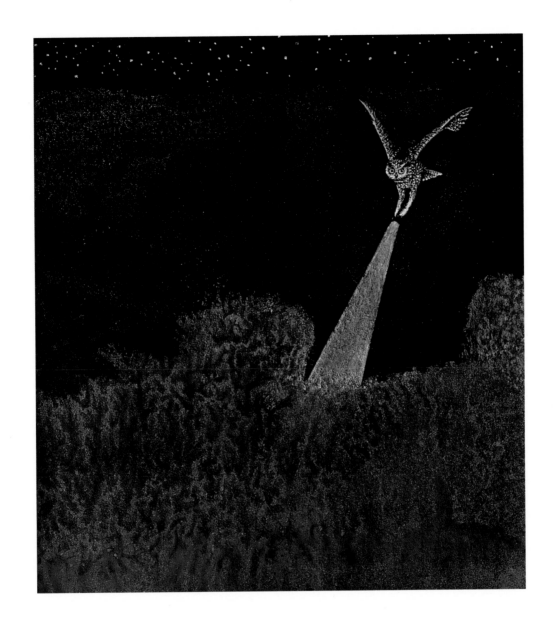

THE SECRET LIFE OF OWLS

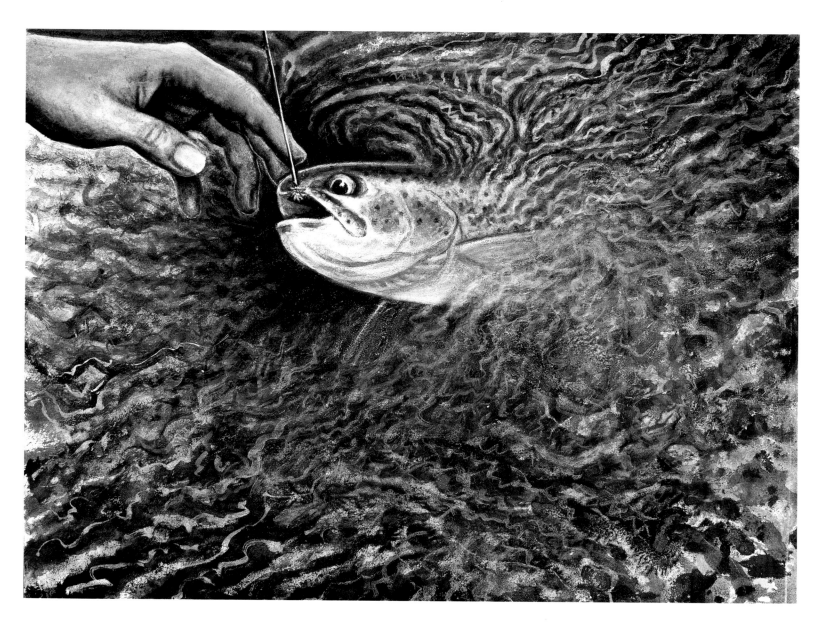

ALIEN ABDUCTION

BEARS, SNAKES, ALIEN ABDUCTION—ALL WITH PARKS REECE

by Scott McMillion

It was March, probably 1980 or 1981, and Parks Reece was setting up folding chairs in the Danforth Gallery in Livingston, Montana. March is a miserable time in Montana. It's too windy to fish, too muddy to leave the pavement, and we're all too broke to go anywhere. Parks was running the gallery in those days and he hadn't been around long enough to lose his Carolina accent, but he'd been here long enough to understand the misery that March inflicts.

So he arranged to show some Sunday afternoon movies during that month when winter won't let go and spring can't get a grip. I was the first person there, which shows you how bored I was. Parks grinned at me and drawled "Hah," which is Southern for hello, and I said to myself, "So who's this ignorant cracker."

We've been off to the races ever since.

Literally.

A few years later we were on the third or fourth day of a canoe trip down Montana's Smith River when I spotted a black bear eating something in a hay meadow a few hundred yards away. We stopped the boat and watched the bear dismembering some kind of carcass, grabbing it with his teeth and shaking his head like a Doberman with a chew toy.

It was important to Parks that he know just what the bear was eating. So somehow I let him talk me into sneaking up on three hundred pounds of hungry bruin so we could surprise it and chase it away from a meal it was obviously enjoying.

The closer we got to the bear, the less I liked this idea. Parks said not to worry.

"What," I snarled. "You think you can outrun that bear?"

"I don't have to," he replied. "I just have to outrun you."

And that's what it's like, going out to play with Parks Reece. His curiosity tends to bring on adventure.

If the fishing's good, he's likely to disappear until well after dark, when he'll turn up wet and scratched and bruised, but happy.

If the fishing's bad, he's likely to get naked, climb a tree or a cliff and shout at people.

He can run really fast, and sometimes he has to, but it still takes him all morning to get in the car.

And considering his interests, he's hardly ever in the hospital.

In addition to bears, he's been known to play with alligators in the Florida swamps, take his drift boat through the rapids at midnight, and play with rattlesnakes in his own backyard, an activity best undertaken with a certain amount of concentration.

He had captured a particularly large specimen one day and wanted a picture of it. Parks held the snake behind the head and I had the camera. Parks relaxed his grip for a microsecond. The snake saw its chance and tried to bite. It missed, but not by much, and Parks wound up with snake venom dripping off his thumb.

Later, he said it tasted like antifreeze, which raises a couple of interesting questions.

Like I said, he's the curious type.

We've had some long distance adventures in places like Mexico and Florida and Argentina, but the best ones have been closer to home here in Montana. We've been stuck in the mud and we've been lost in the darkness. We've been punched full of holes by prickly pear and left hypothermic and mumbling by a blizzard that surprised us one Halloween.

We've been rendered speechless on occasion by strong drink, I will admit, but we've also been struck dumb by the northern lights, shivered by the call of a bugling elk, and rendered clueless by the sounds that something made down in that coulee.

Lost in the Missouri Breaks late one night, we saw a funny light in the distance, which quite naturally started a conversation about UFOs, which led to alien abduction, which of course led us to ponder fishing, specifically the catch and release variety.

What, we wondered, would a fish tell his friends after being snatched from his world, weighed and prodded, measured and photographed by huge and powerful aliens, creatures that somehow existed in a place where there was nothing at all to breathe?

Would they believe his story?

But even if they didn't quite buy it, could they ever look at the sky in quite the same way again?

Spending time with Parks is kind of like that.

You'll probably find yourself wet or cold, sunburnt, dehydrated, frostbitten, or in some other way physically miserable. There's a good chance you'll suffer from mosquito bites and poisonous cactus spines. You might get kicked by a deer, bitten by a dog, poked in the eye with something. You could burn your finger or smash it in a door. You might watch your boat float away without you. You're likely to have a flat tire and run out of gas, maybe both at the same time. You'll get hungry and hungover. You might suffer an incredible fright.

When you get back to town, nobody will believe your story. If you've got any sense, you won't even try to tell the whole thing.

But one thing is for certain. You weren't bored, mostly because Parks refused to be.

And like that fish, you've got a new perspective.

You've seen the other side.

Parks showed it to you.

And it's a very curious place.

ALLIGATOR

by Michael P. Haymans

Slipping through the water
With the wave of my tail
I'm hunting.
Birds and snakes and fish—
Beware.

Dark red water
Over blackened scales
Lapping,
Silent as death a few days old—
Be scared.

Cypress knees
Are not what I am
After.
The marrow of your bones
The crackle of your joints—
My fare.

Turtles are crunchy
And fun to toss in the air,
But yapping dogs and children who cry—
There's more there.

Faster than a horse
For a short distance,
I'll grab and spin and take you
To my lair.

There you'll rot forever
Until I eat you.
Putrid flesh on my breath
Smile fixed—
I glare.

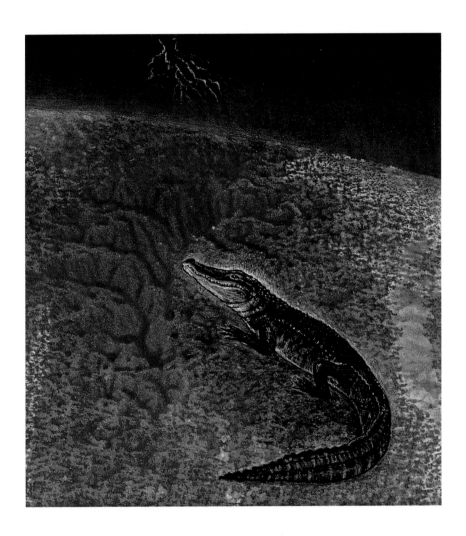

SOON IT WOULD RAIN CATS AND DOGS

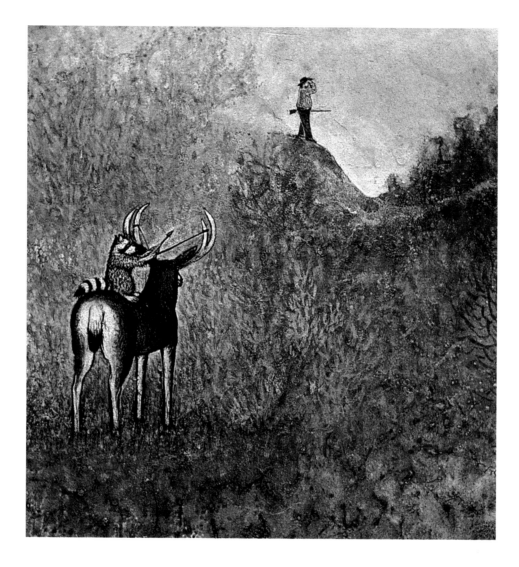

HAZARDS OF HUNTING

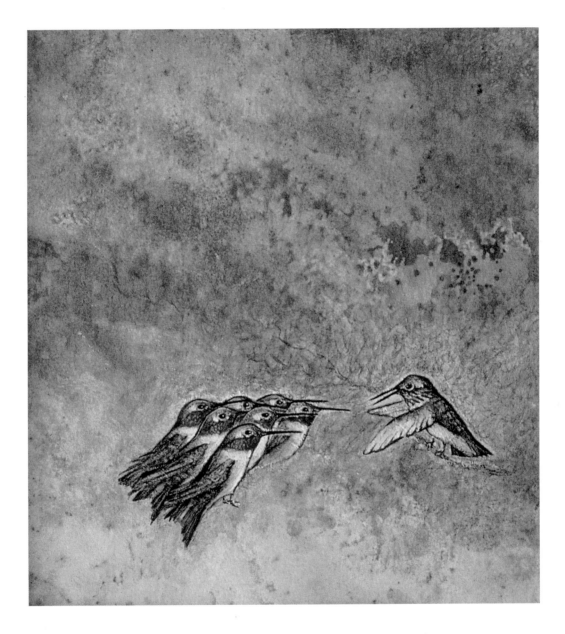

THE ONE WHO LEARNED THE WORDS

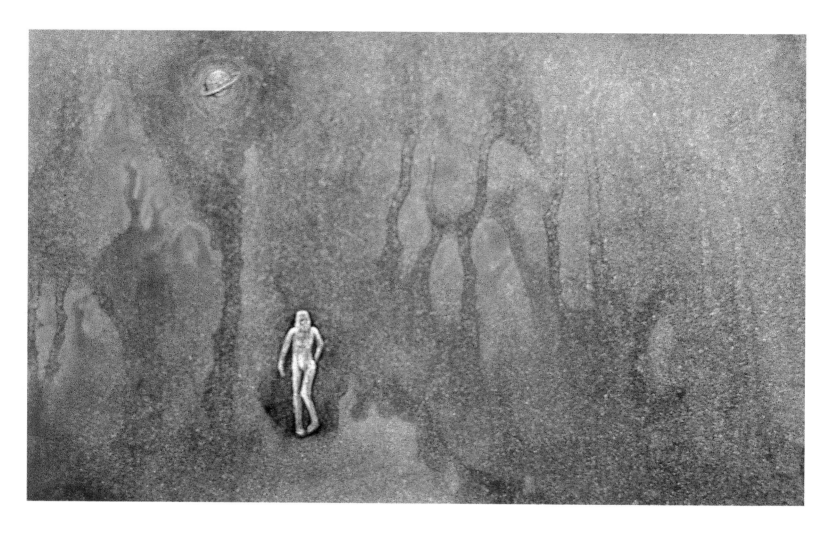

ASTEROIDS

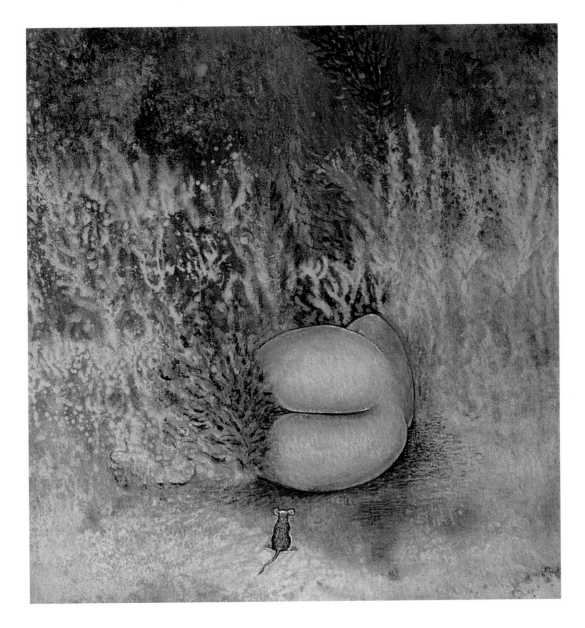

THE EYELESS MONSTER SMILED

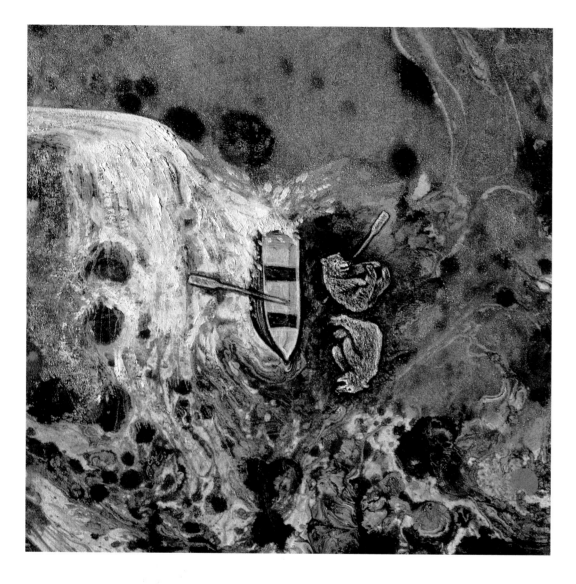

BEAR PROBLEM ELOPEMENT

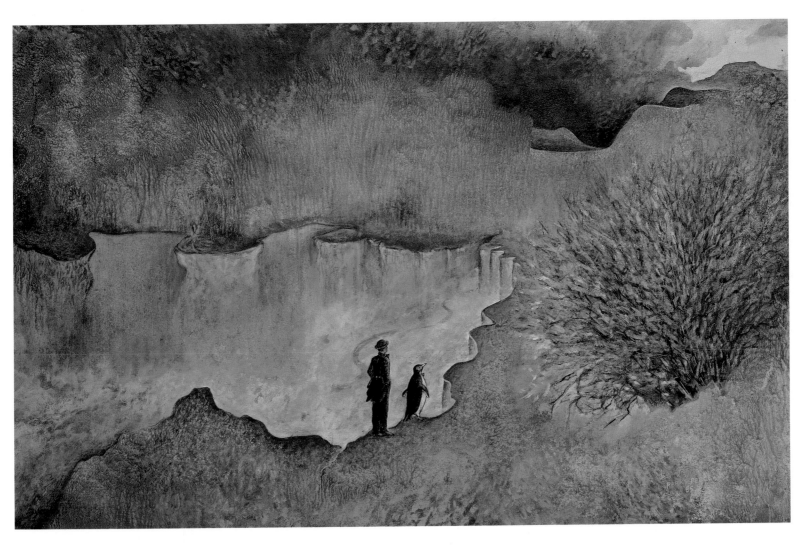

A Tale of Two Tails

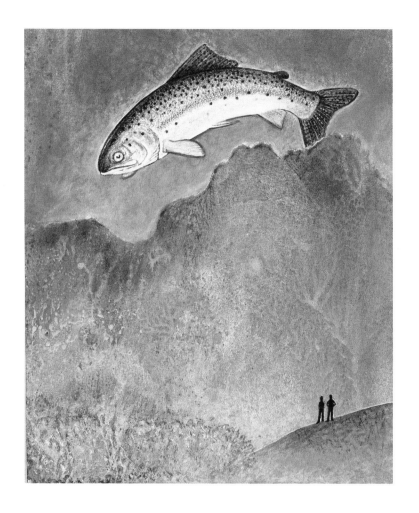

THE GRANDEST RAINBOW IN MEMORY

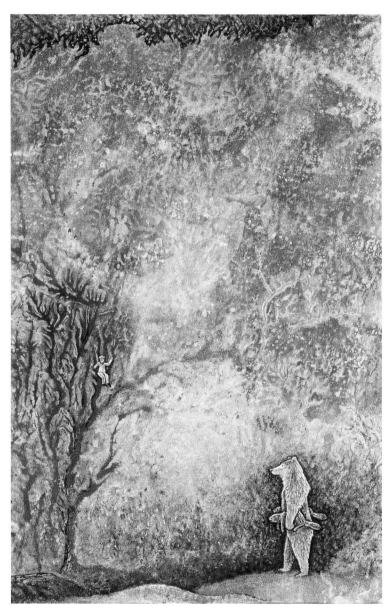

GRIZZLY TOOLS

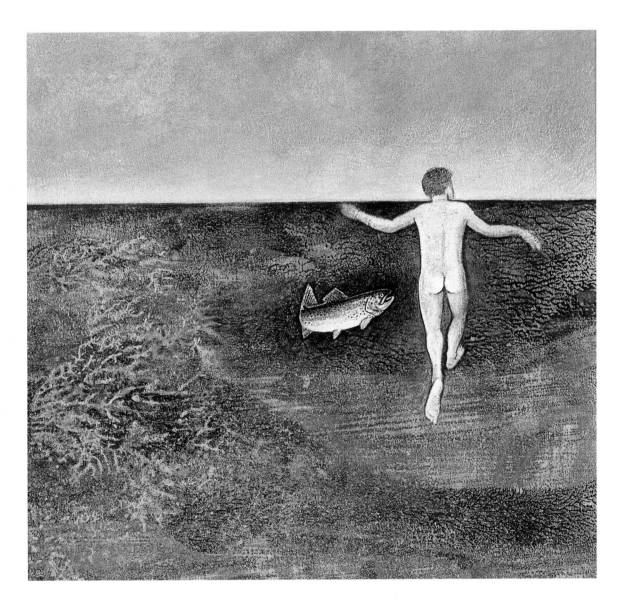

RAINBOW ON A WORM

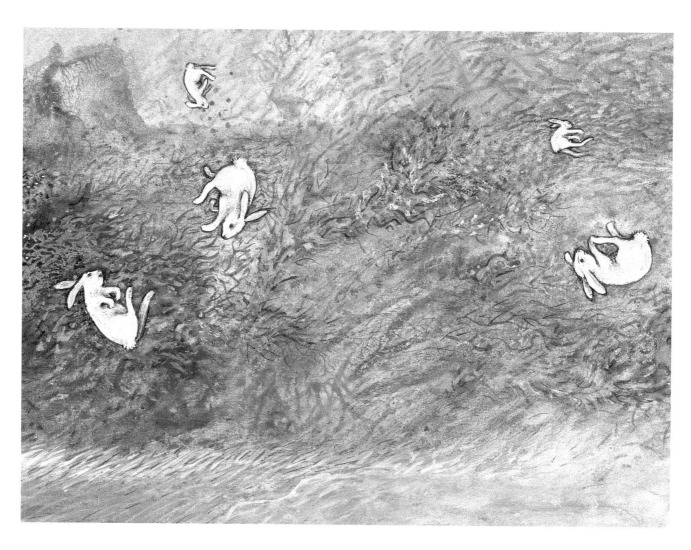

RABBITS' FEET AREN'T LUCKY IN HURRICANES

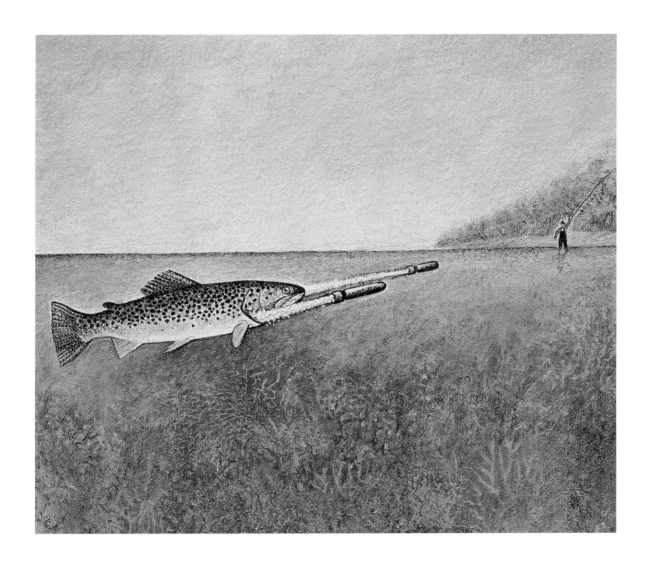

FIRE TWO!

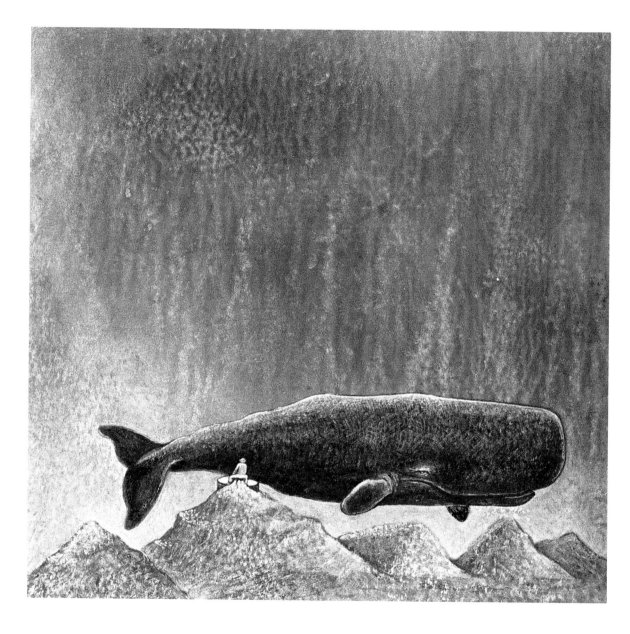

MILKING TIME IN ATLANTIS

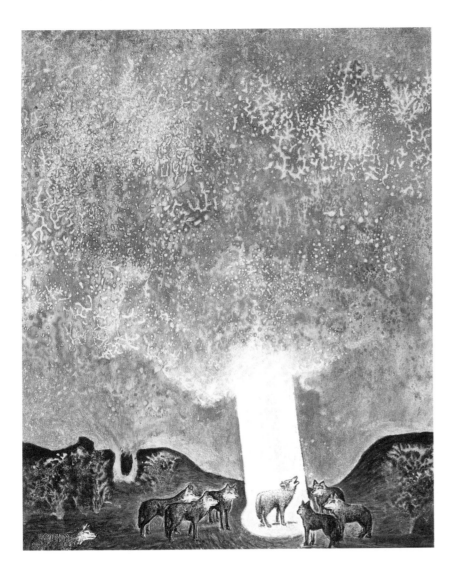

THE REAL LEADER OF THE PACK

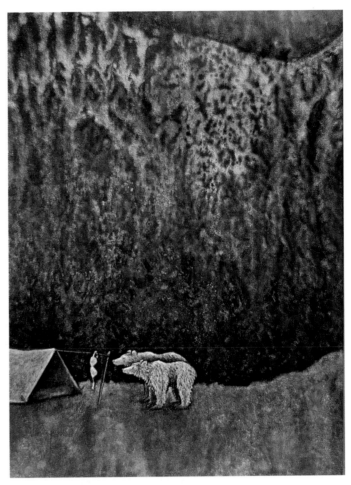

MYSTERY OF THE
DOUBLE-BARREL SLINGSHOT

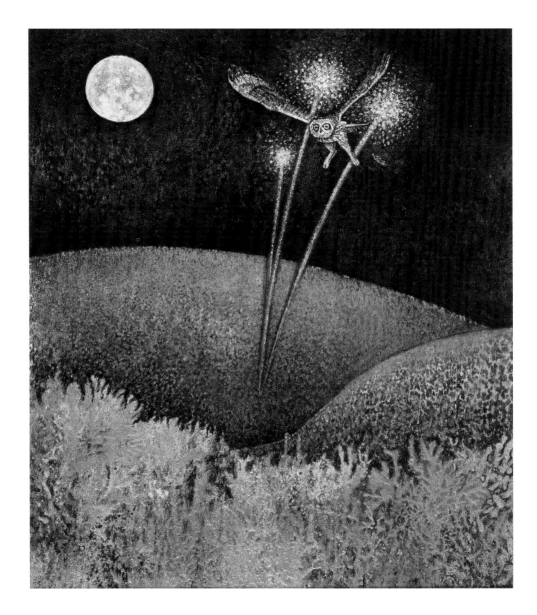

MOUSE DEFENSE SYSTEMS

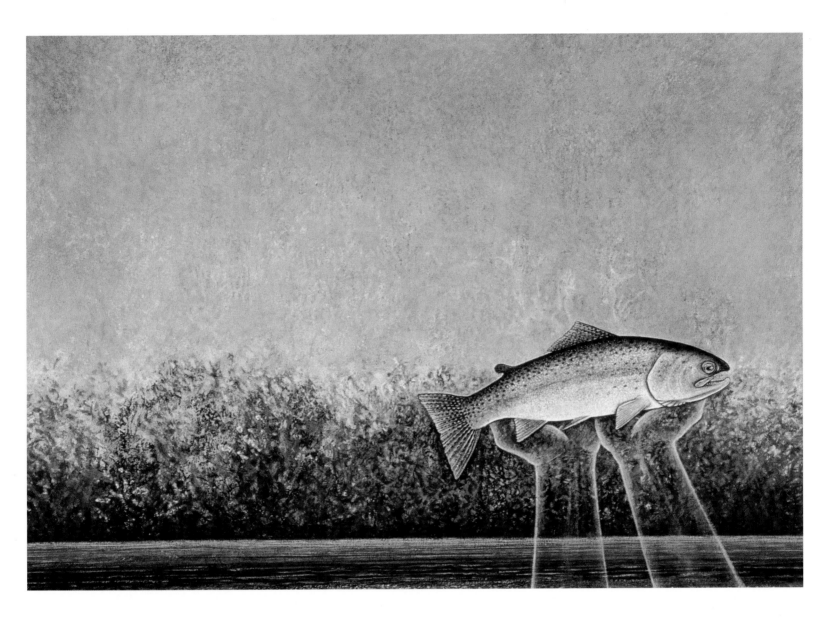

THE GIFT

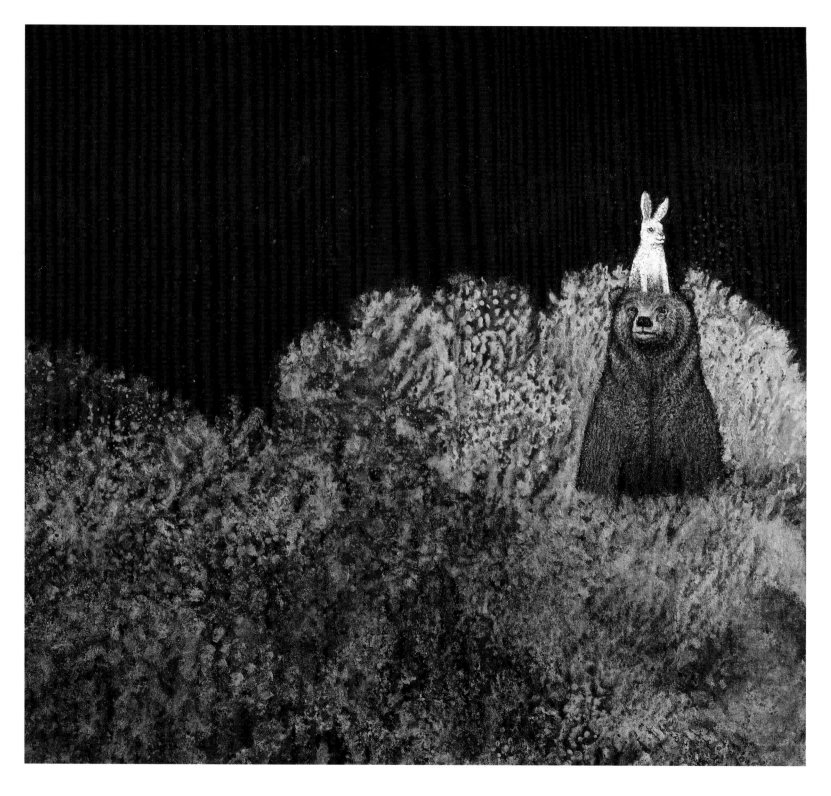

GRIZZLY HARE

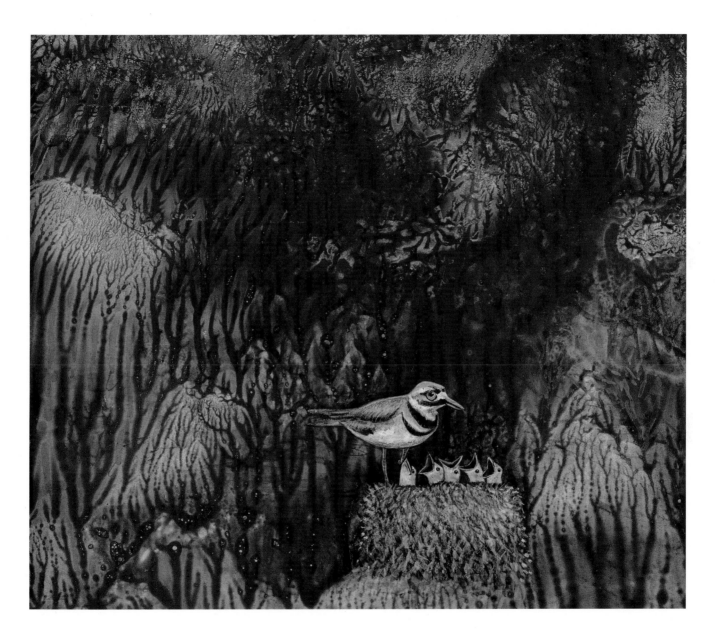

LAST OF THE RED HOT PLOVERS

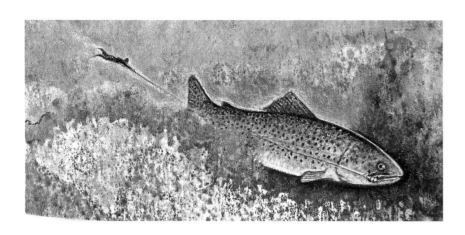

FISHING THE YELLOWSTONE

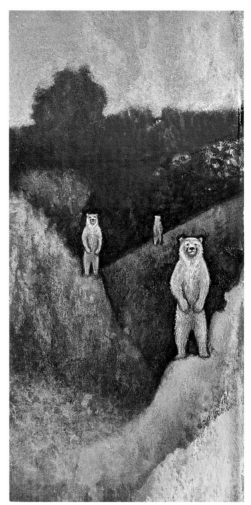

GRIZZLY, GRIZZLIER, GRIZZLIEST

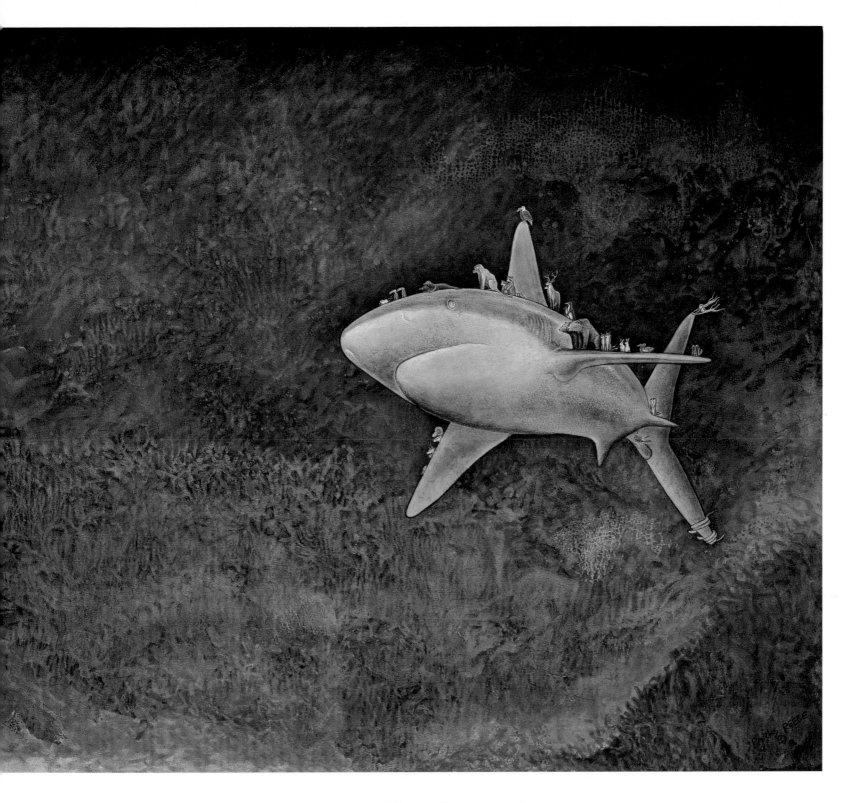

NOAH SHARK

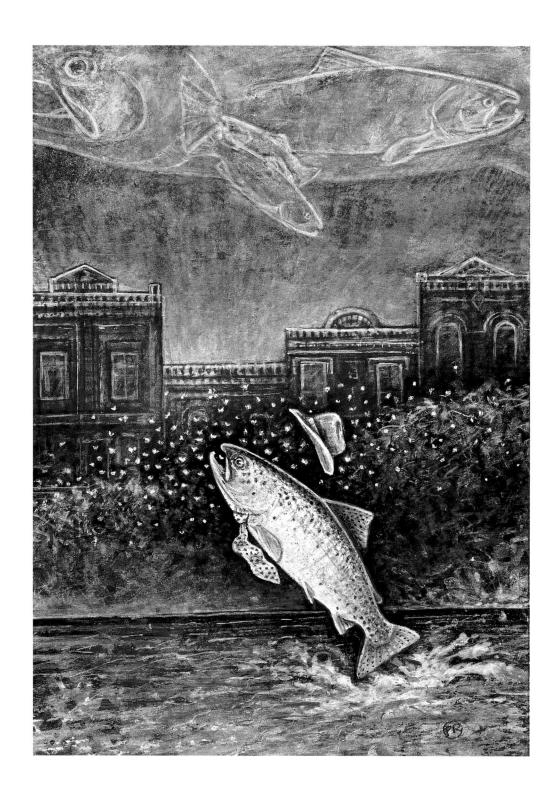

TOWN TROUT

CITY LIMITS

by Greg Keeler

Behind the stockyards, trout are taking nymphs,
So you ditch the evening news and hit
The stream. On the first cast you get
A rainbow, a piggish wallowing blimp
Of a fish. It's headed for the biker bar
Downstream and into your backing when
It finds a rusted turquoise Plymouth fin
And breaks off. On the road, a car
Squeals to a stop beside you. "Must of been
A whale. I saw it get away. What did
You use?" says a pizza delivery kid.
"Hopper imitations," you lie, "size ten."
The next evening, that pool you once enjoyed
Is full of hopper slinging pizza delivery boys.

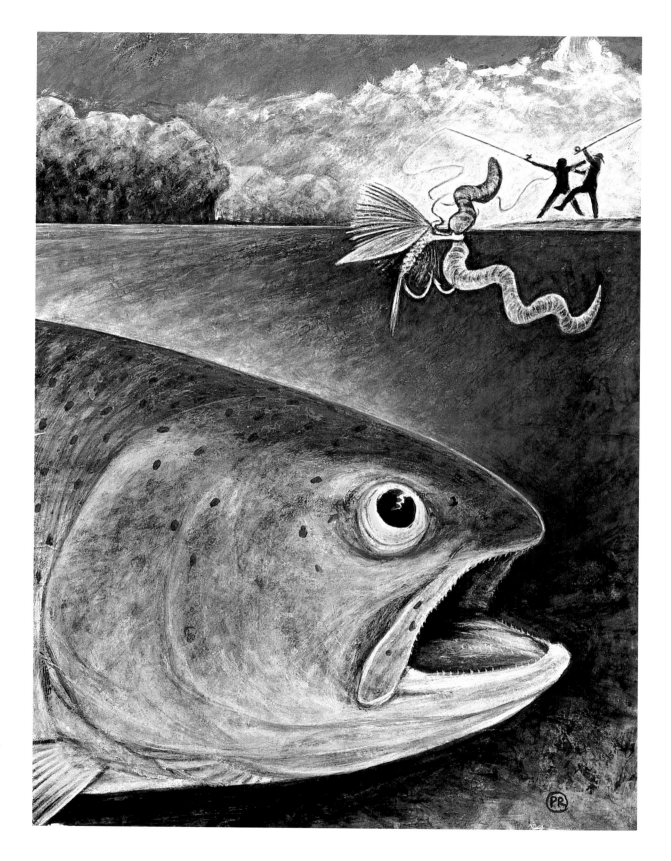

DEBAIT

STREAMSIDE STEREOTYPE SONNET

by Greg Keeler

"I'm gome ketch me wun big sombitchin' trout.
Gimme them crawlers, Roy Dean, pronto. I seen
A hawg of a rainbow roll somewhere between
Them two rocks—no not there, out
Further—out near where that there stout
Fella with the fly pole's comin'. I mean—
Hey! Whutha hell's he doin'. I seen
'Im first. Gitcher pansy-ass out
Of my hole, yew yuppie piece of crap."

"Beg pardon? It's a bit of a strain
Hearing you. Please speak up old chap—
That is, if speaking doesn't tax your brain
Too much. Now see here—don't throw that stone,
Lest I fall and drench my cellular phone."

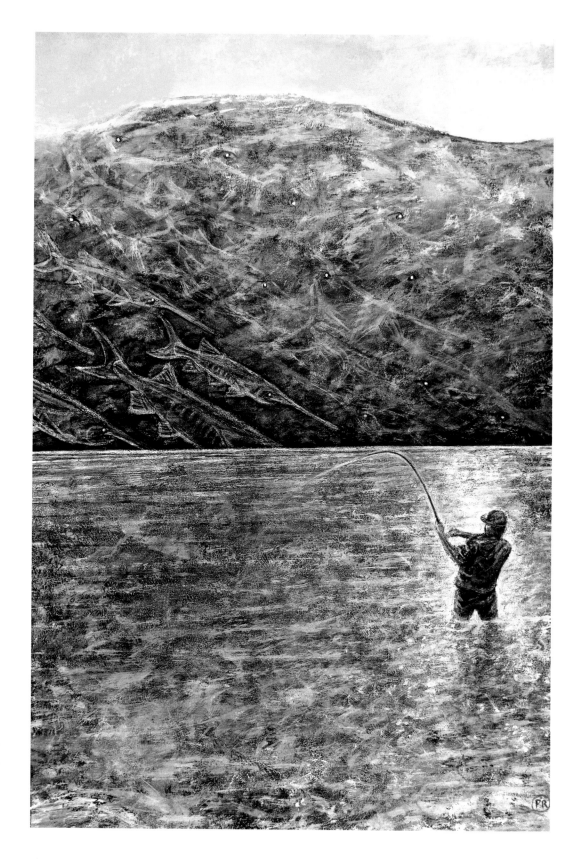

REELING IN THE PAST

A PALEOLITHIC CAPER

by Greg Keeler

So Bubba snagged a paddlefish without
A thought of history. Without a flinch
Or glitch or itch, without budging an inch,
He jerked and hooked its stunned and funny snout,
Then reeled it in then pulled it out and shouted,
While he gave himself a little pinch,
"I must be dreaming. It's damn sure a cinch
That I'm euphoric to catch this porky, stout
And prehistoric critter. It's nose is like
A spatula. It's skin is like sandpaper.
I'd swear it swam from fossil rocks or hiked
Out of a nightmare in a Paleolithic caper.
What secrets must this chubby fellow know?
So, what the hell, I guess I'll let him go."

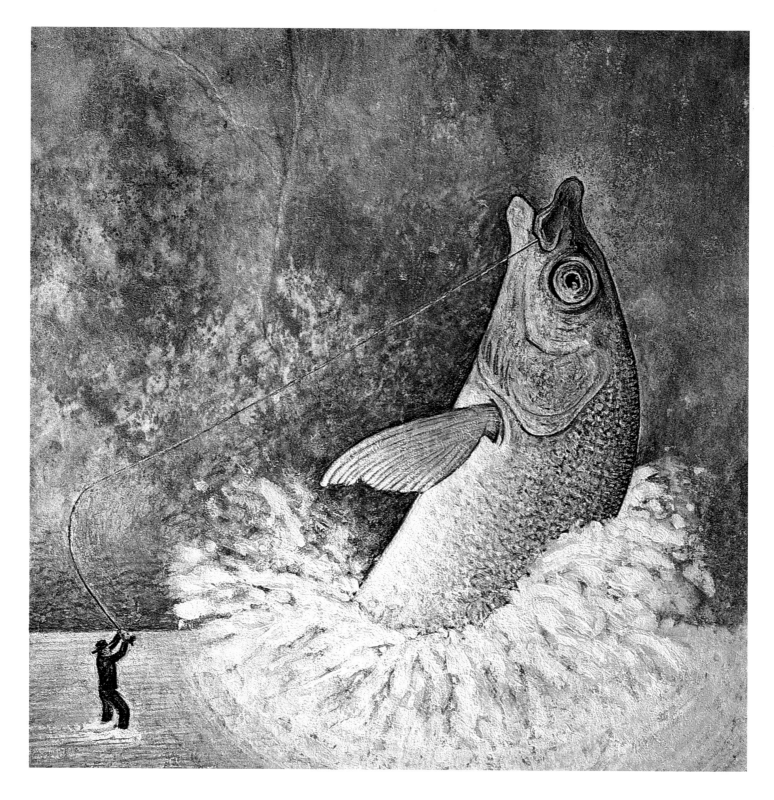

TROPHY OF THE YELLOWSTONE

THAT HUGE RUDE TUBE

by Greg Keeler

I'd fished in many waters and many a mile
I'd trod, the day I caught the whitefish, twice
As big as God. Its lips were HUGE, Christ
Only knows how this weak and trembling child
Escaped their suction, for in their hoovering, wild
And strong, they caused immense destruction. Nice
People might have turned and hurled, the price
They'd pay for ogling that huge rude tube, that vile
Hole furled, that frenzied feasting gargling which spewed
Around its vast consumption of everything in sight.
I barely had the gumption to approach those lewd
And slobbering lips and release their ferocious bite
That I might retrieve my little fly that looked
Like my deepest, darkest fears tied to the hook.

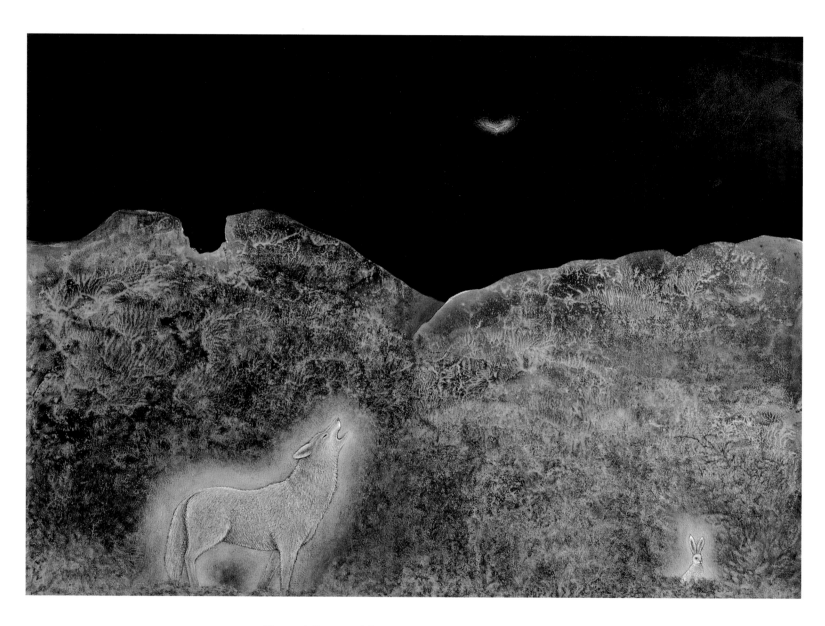

ONE NIGHT NEAR THE NUCLEAR PLANT

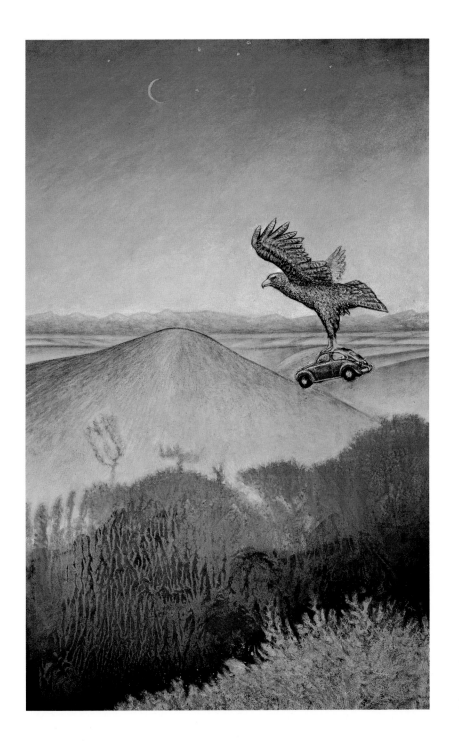

WHY THEY QUIT
MAKING THE BUG

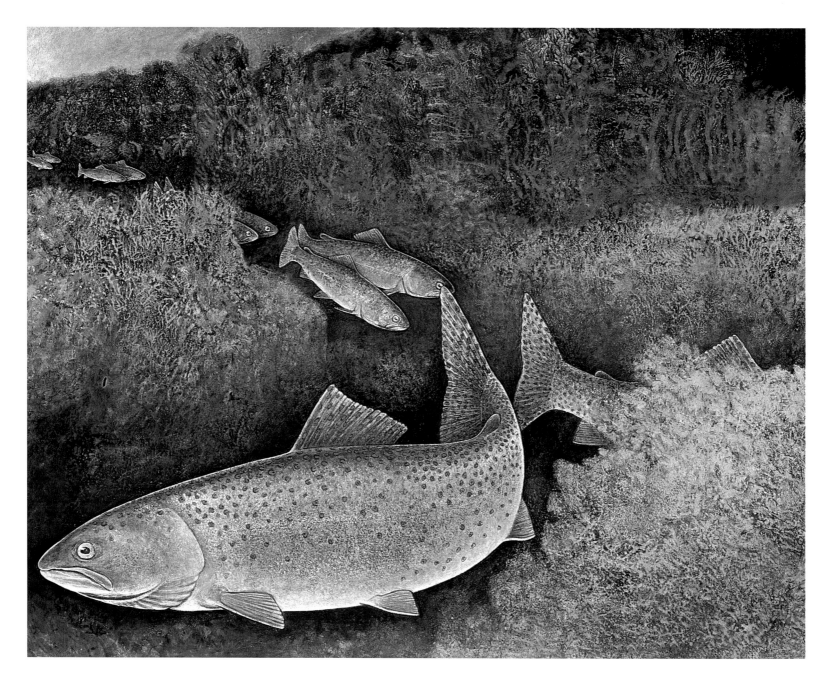

AFTER THE OIL SPILL

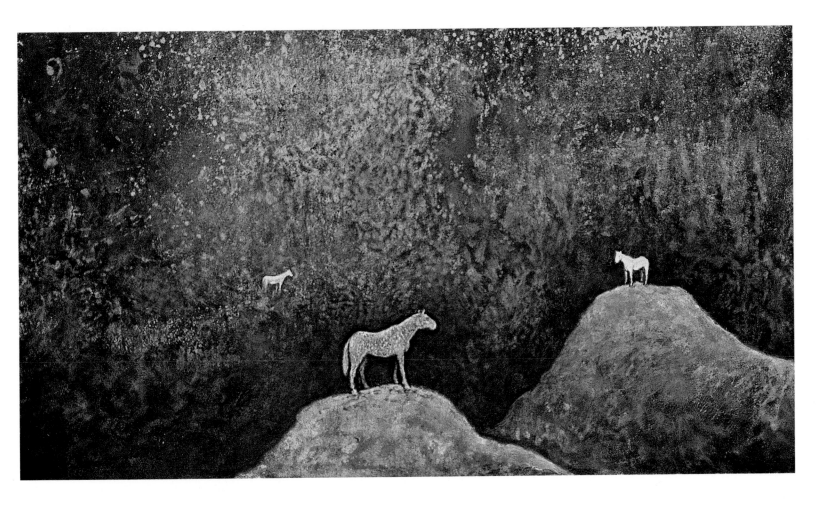

A Horse of a Different Color

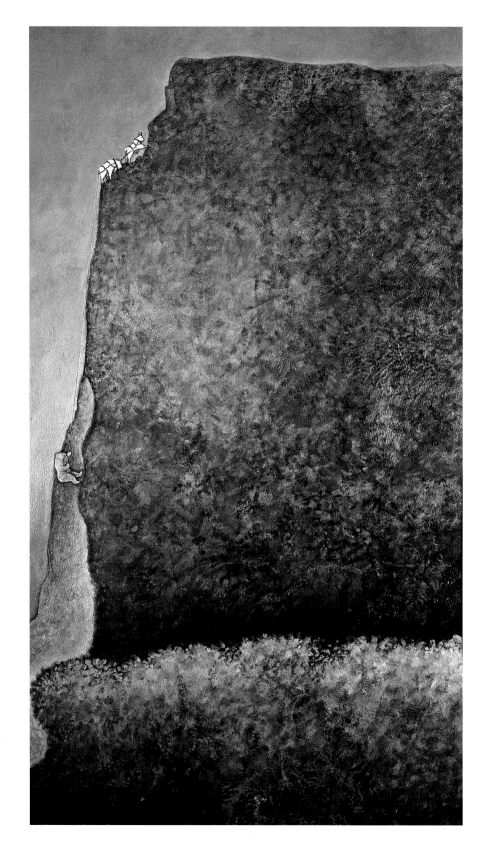

ROCKY MOUNTAIN FERRY

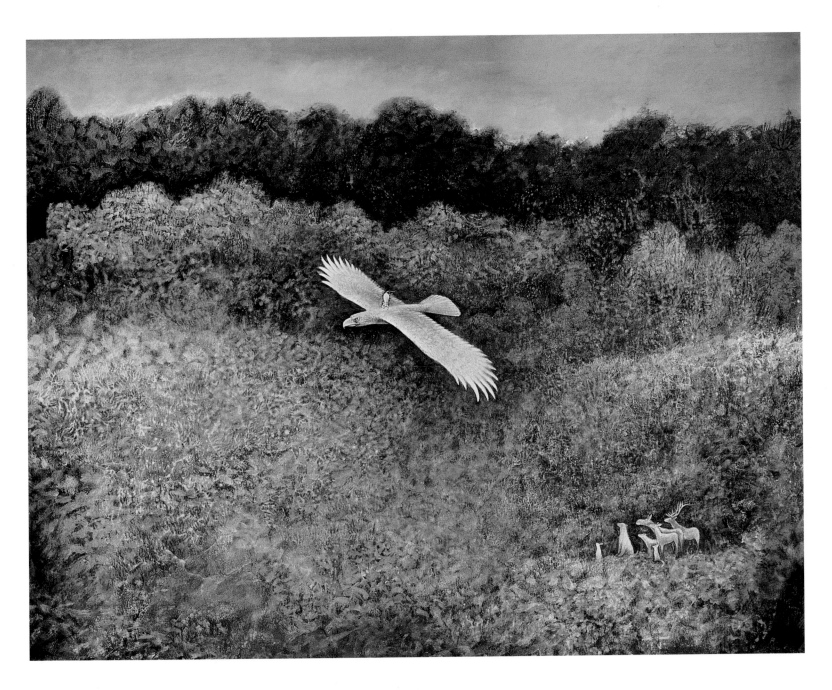

AIR SHOW

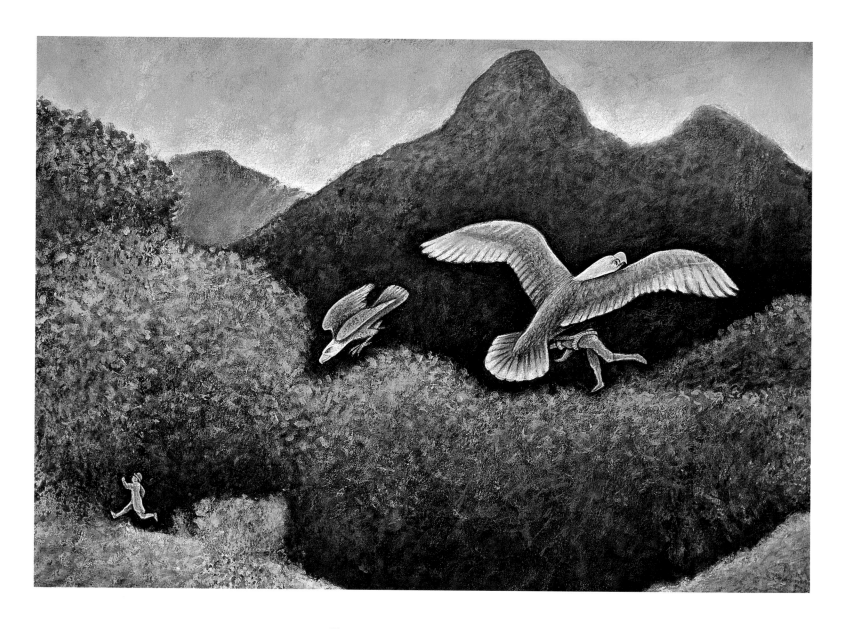

CATCHING LEPRECHAUNS

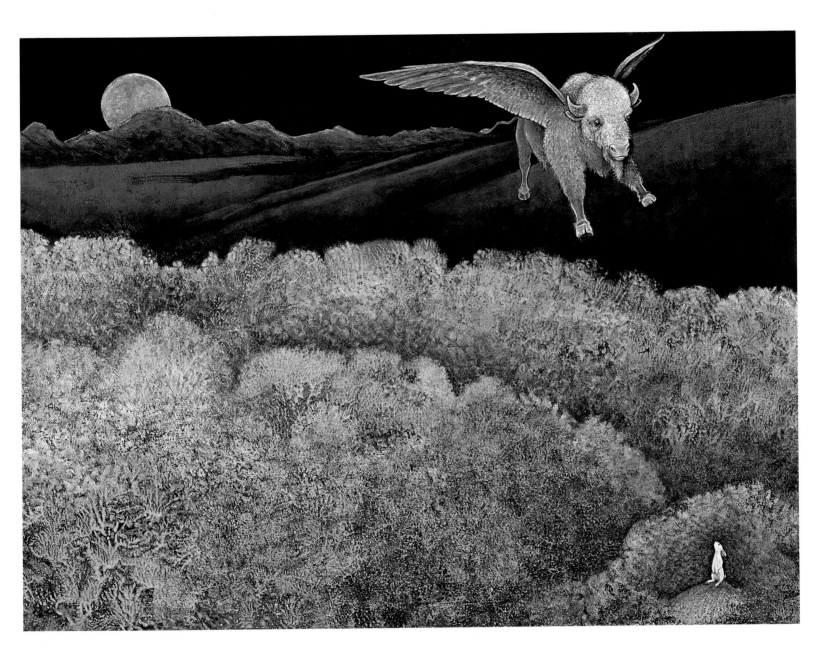

PRAIRIE PEGASUS

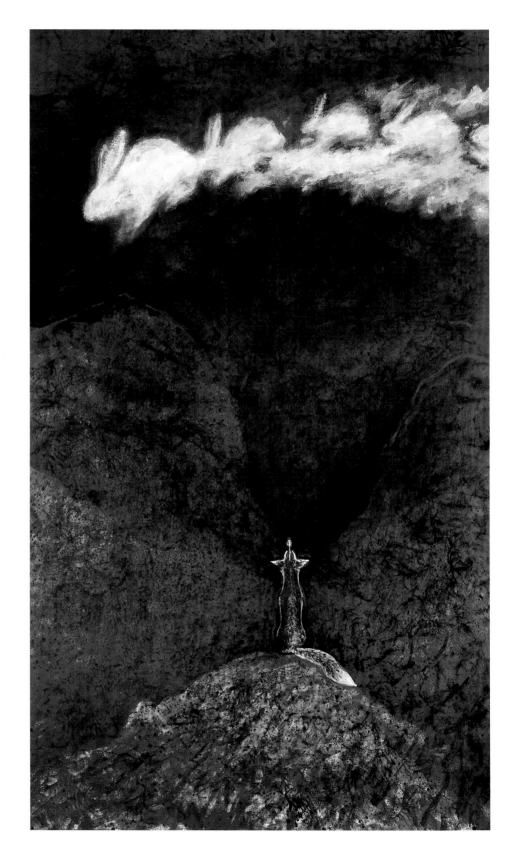

AMID A SUMMER NIGHT'S DREAM

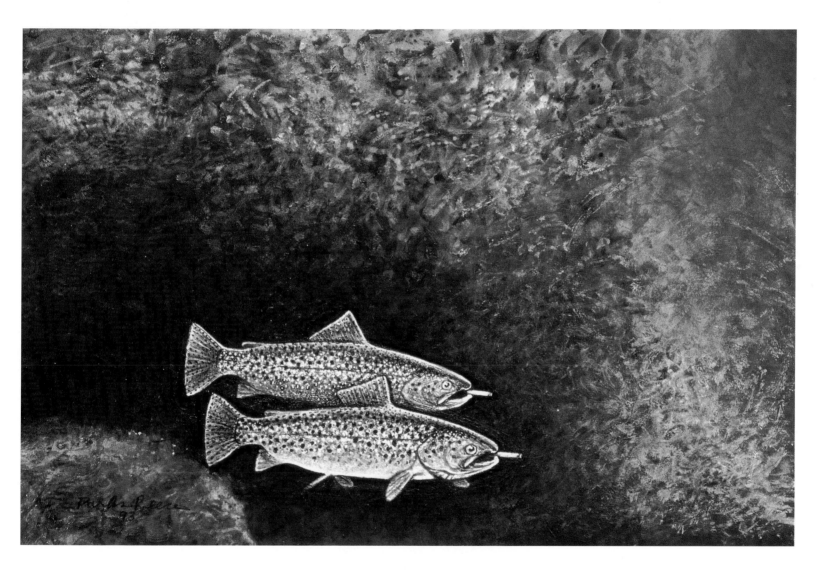

After the Spawn

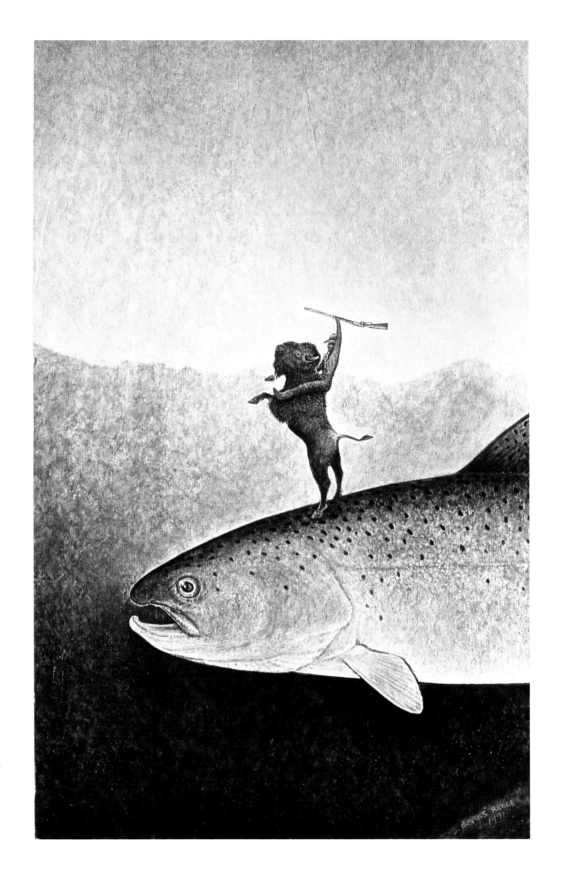

GOING TO MONTANA

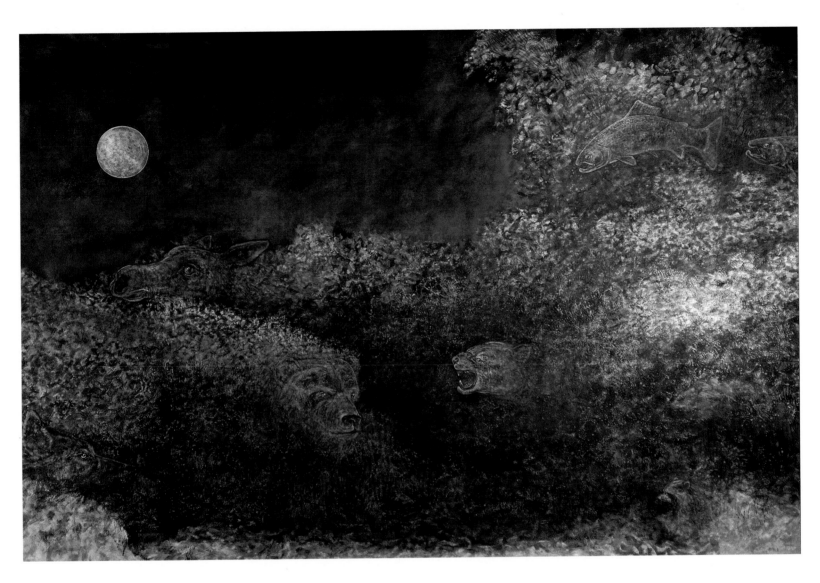

METAMORPHICAL OF OMAHA'S WILD KINGDOM

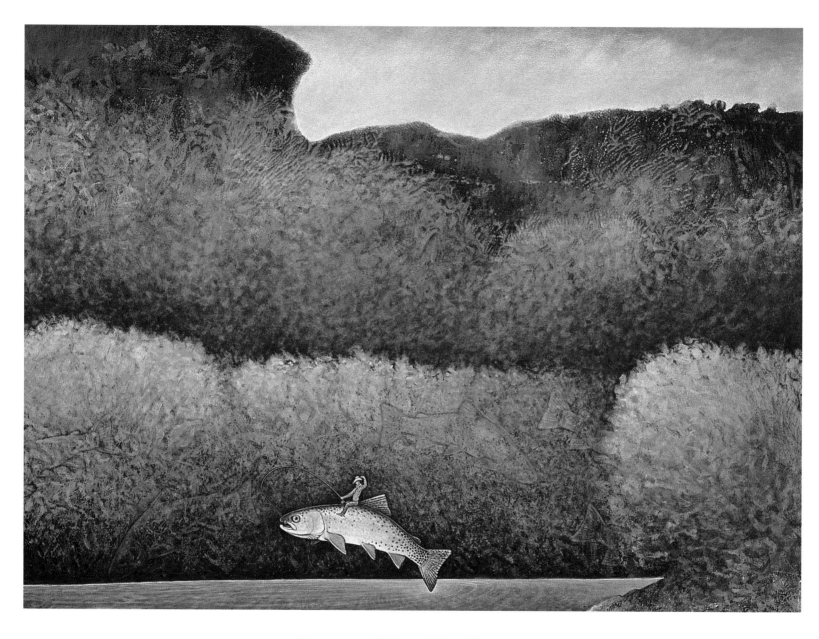

HOW THE WEST WAS FISHED

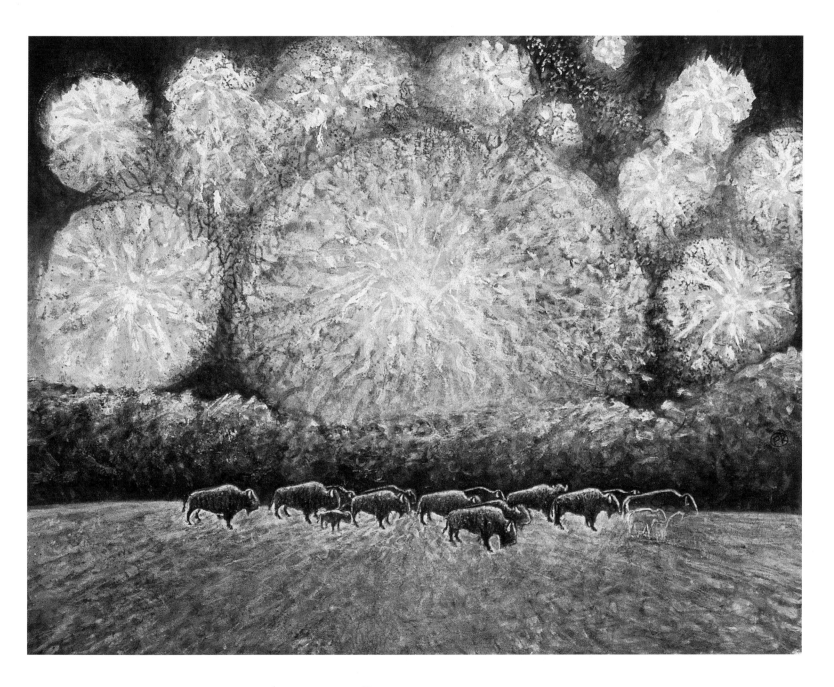

BISONTENNIAL

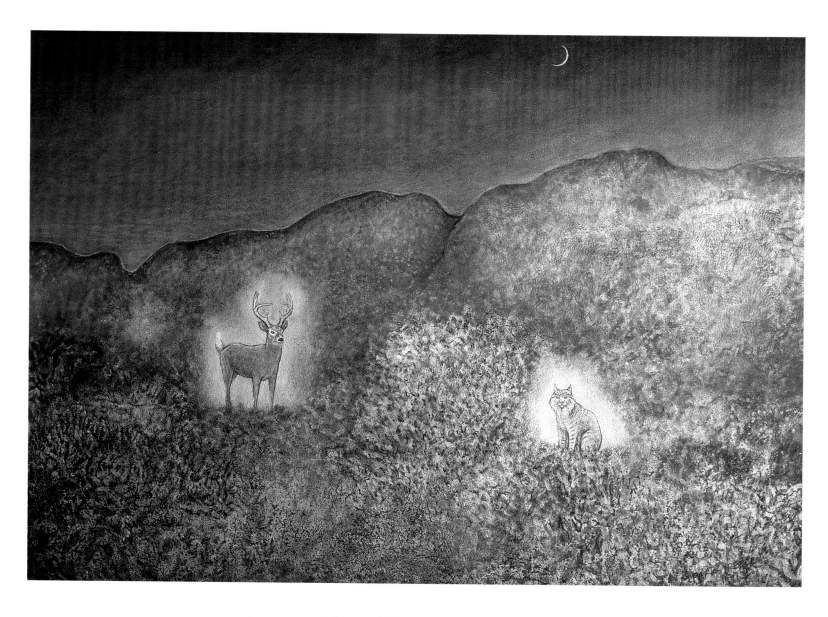

ANOTHER NIGHT NEAR THE NUCLEAR PLANT

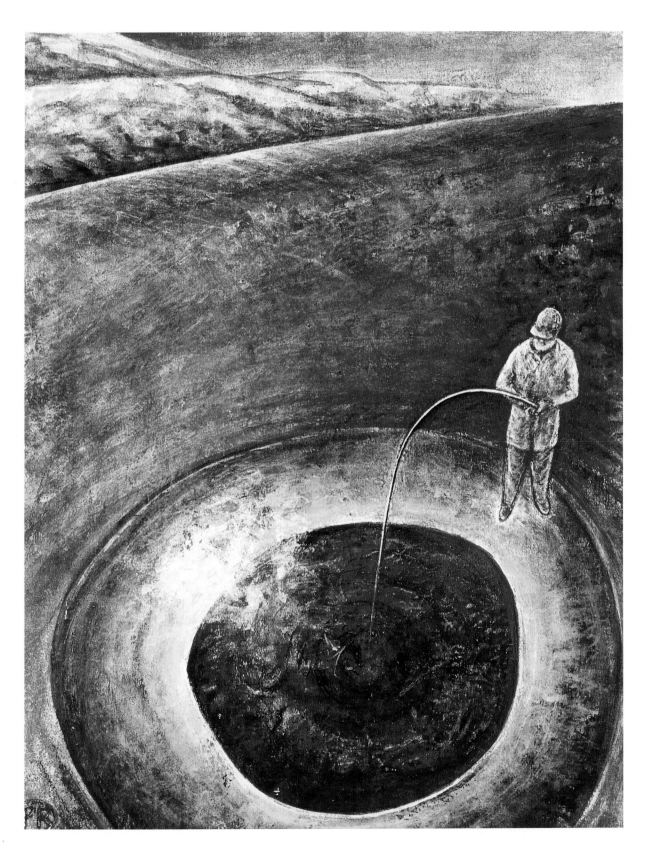

EYES FISHING

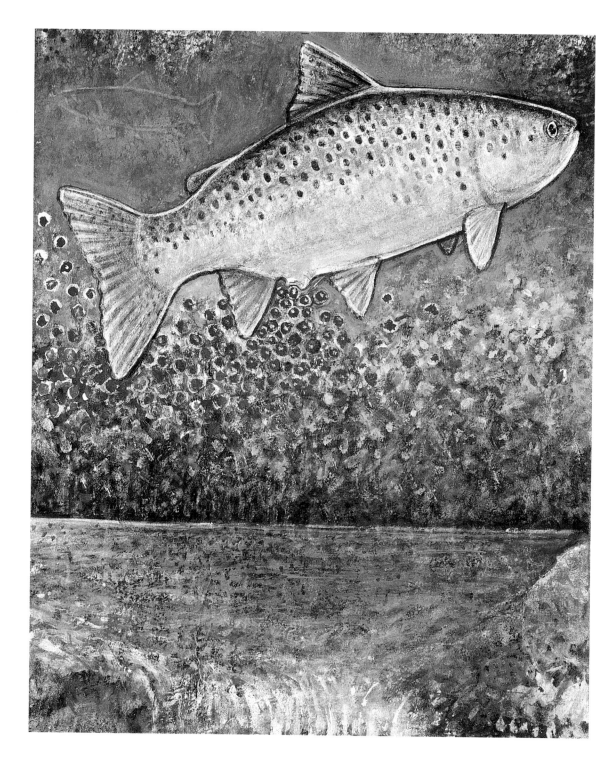

BIRTH OF AUTUMN

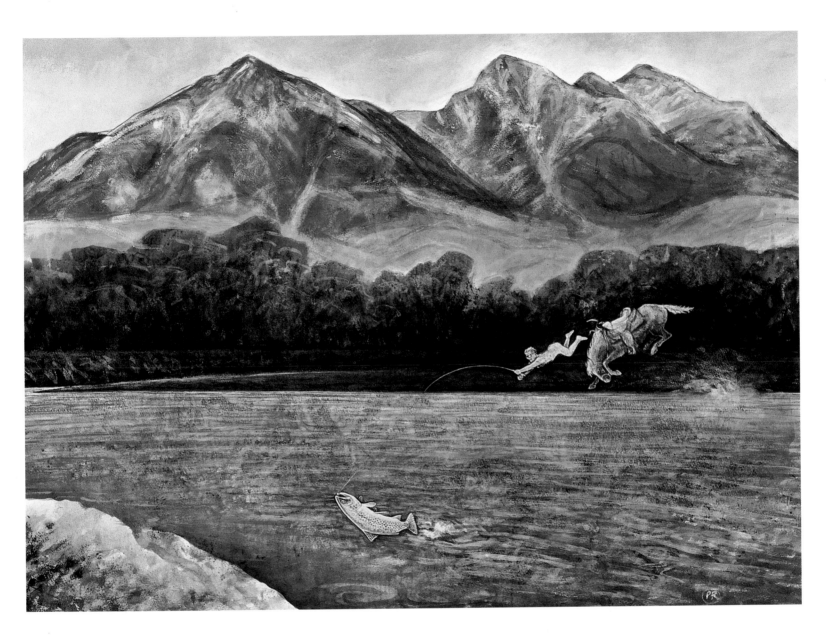

RODEO FLY FISHING

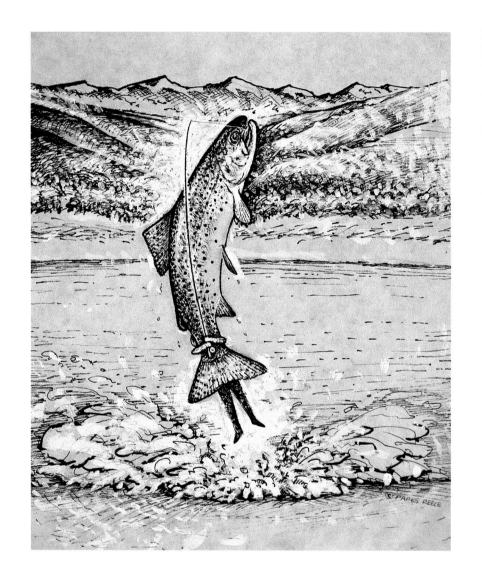

MONTANA BALLET

THE PREDATOR

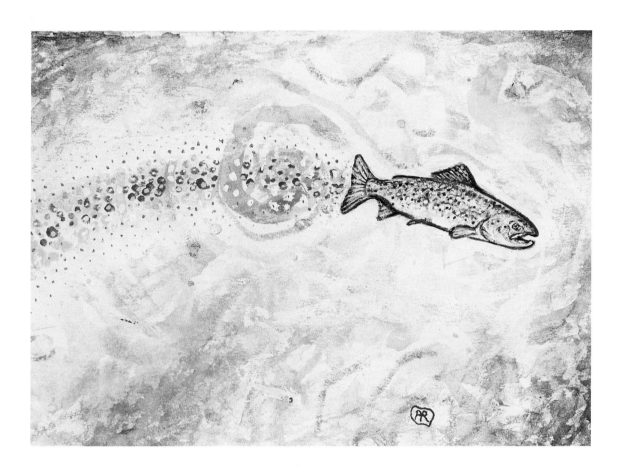

THE FIRST RAINBOW

In August 1992, my friend Tom and I were high in the Absaroka Mountains of Montana, gathering flat shale rocks to build a walkway. It was a week before my wedding. Tom was easing his loaded pick-up down the narrow, winding, dirt road when the soggy shoulder gave way, sending the truck rolling down a small cliff. I was catapulted from the vehicle some thirty-five feet, upside down and head first, into the muddy creek bank below. When I came to, I figured my friend, who had suffered dismal luck with marriage, had tried to save me from the same misery he had endured. Though I appreciated his concern, a mercy killing was not at all what I wanted. So I was quite happy he had only broken my right arm and caused a few stitches. But since I am right handed, my prospects for painting in the immediate future didn't look good. Not to be deterred, I picked up a child's watercolor paint set and during the next couple of weeks completed a series of left-handed paintings. To my amazement they were well received and people actually asked to buy them. Here is one of them.

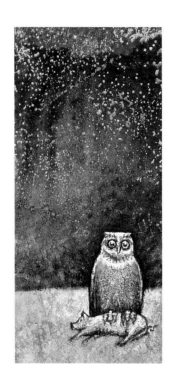

THE DREADED
CHOLESTEROWL

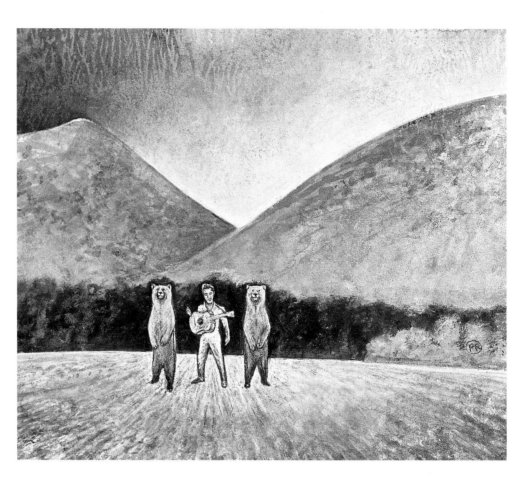

ELVIS SIGHTED IN MONTANA

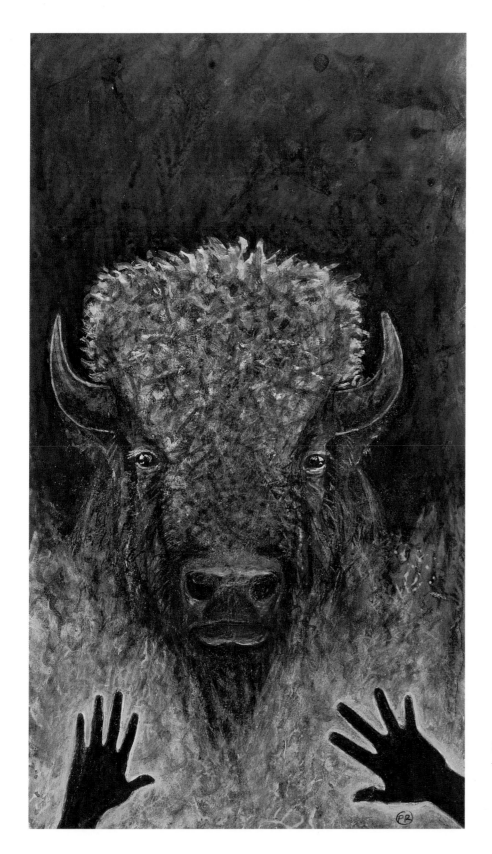

ONE NIGHT BY THE CAMPFIRE

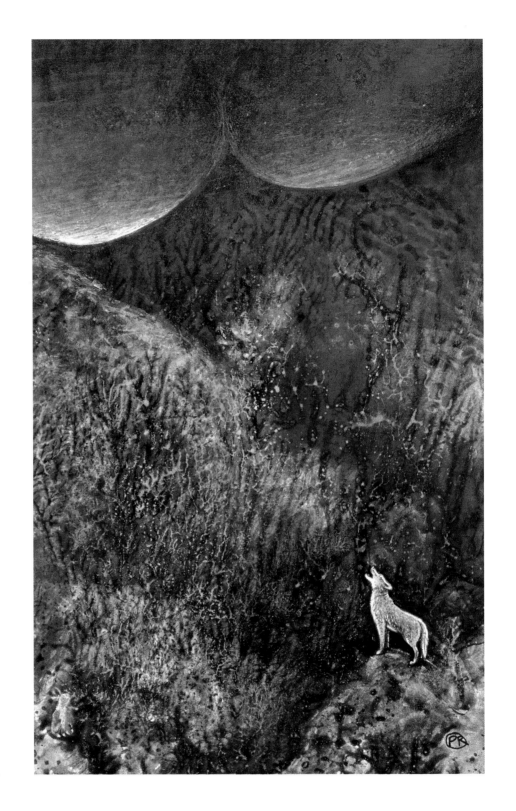

THE CRACK OF DAWN

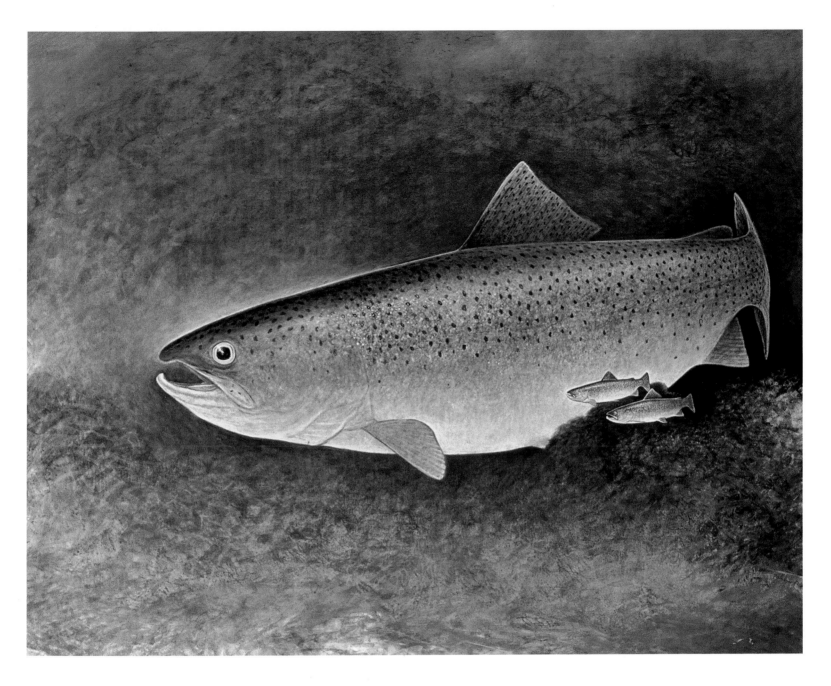

Downstream From the Steroid Factory

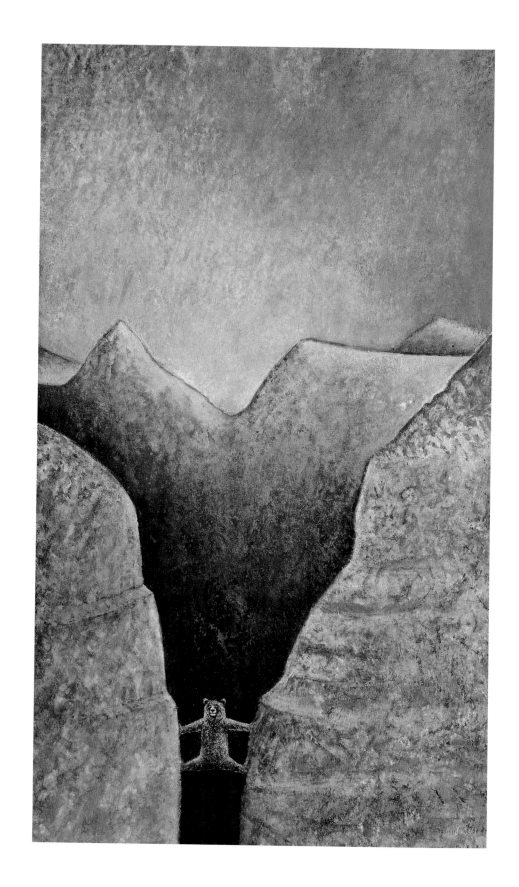

A Natural Born Climber

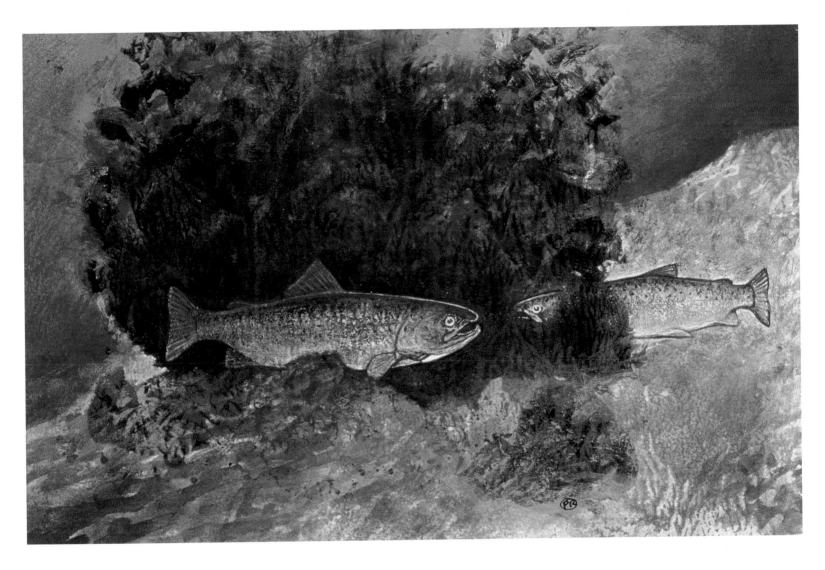

CONFESSION

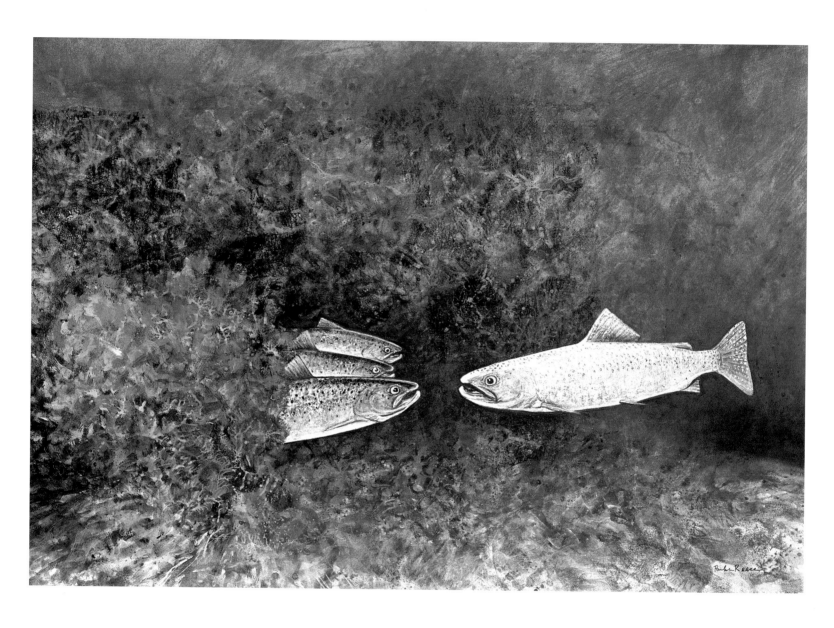

SCHOOL MARM

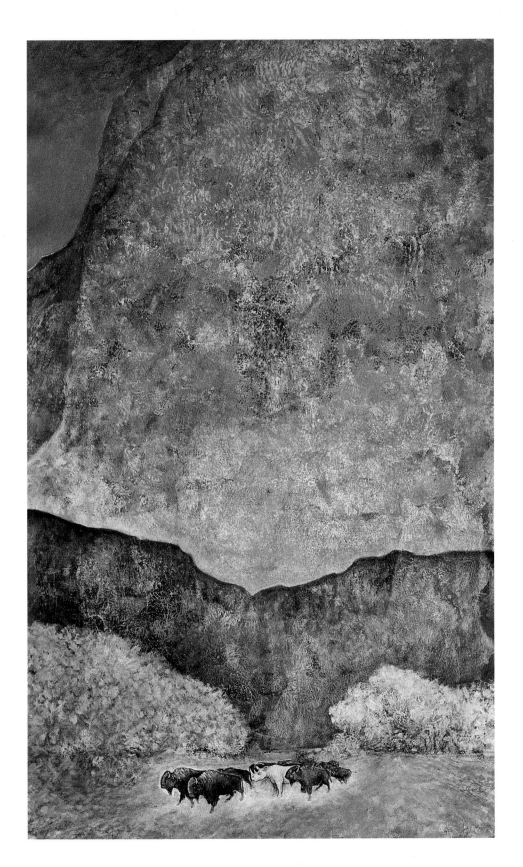

STRANGER IN A STRANGE LAND

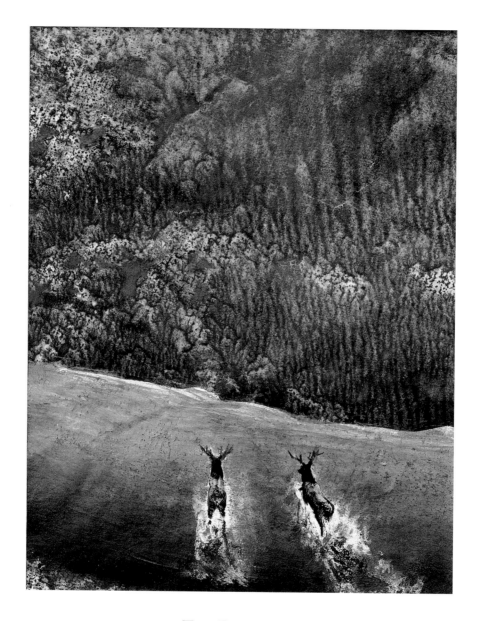

THE RUT RACE

BRINGING UP DADDY

by Myers Reece

Remnants of my childhood plaster my refrigerator door. Most of the collection consists of ordinary family pictures, but one photo really stands out: a snapshot of me, as a five-year old, sitting on my front porch next to a dead porcupine much larger than I was, bristling with quills and close enough to give me a hug, which was what I was afraid of. I didn't want to snuggle.

My dad had found this gargantuan and well-armed rodent lying on the side of the road, so he naturally took it home with him. Most people would zip right past a mess like that, though some odd individuals might stop and take a picture, simply because of the creature's size. But my dad isn't most people. He likes road kill. Of course he took it home. He paints wildlife and this was research. Or at least that's the way he justifies this kind of behavior.

He posed the beast in a few positions, then decided to incorporate me into the picture. Nervous as a bug in a chicken yard, I followed orders and sat next to the frightening corpse, keeping my eye on my picture partner.

For my dad, this was just another father and son bonding experience.

For me it was a lesson in how my dad perceives animals, the natural world, and our strange role in it: he likes to take a closer look than most people do.

I was born and raised in Livingston, Montana, where I still live today, to Parks and Robin Reece. My father, Parks, has made sure my childhood wasn't dull. We have had many experiences similar to those of other families:

camping trips, visits to the zoo, and kicking back to enjoy meals together. But I must stress here that we had "similar" experiences to those of other families, not "identical" ones. My dad led many of these expeditions in the name of "research" for his art.

Take our visits to the zoo for example. One trip happened shortly after the porcupine experience. As my mom, dad, and I meandered through the noise and stench of the captive animals we came across the place where they cage the African cranes. These birds stood at least seven-feet tall, each with a neck like an angry cobra.

A chain-link fence kept the spectators and the birds away from each other, with clearly marked signs warning people to keep their distance. Hoards of people roamed past the birds and all of them, except my dad, managed to stay away from the fence. He wanted a better picture. "Research," he said. He didn't want the fence to show in

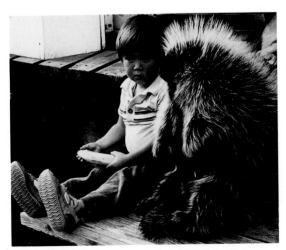

"No, you can't have my banana."
Myers Reece, age four

93

his photo so he pressed his body up against it and poked the lens through one of the holes in the chain link.

As he fiddled with the zoom button he lost track of one of the cranes that had been watching him. When he finally got the camera adjusted, he pointed it at the mighty bird and got ready to snap. But the bird snapped first, aiming for my dad's eye in a lightning fast jab.

Luckily, the bird's beak hit the camera instead of my dad's eye, but it smacked him hard enough to leave a two-color shiner, which, for him, doesn't really count as a wound.

My dad also has some strange ideas about family meals. Throughout my younger years, at almost every meal he would distract me by telling me to look out the window or to go fetch something for him. Then he'd hide my food, plate and all.

I would look away for two seconds, then turn back to find an empty place setting and a grinning father. I stood only a couple feet off of the ground so any place above five feet or so was impossible for me to see. All that my dad had to do was set my plate on top of a nearby cupboard, then lean back to enjoy my search.

I quickly learned that asking where my food was did not produce answers, only clues. It was a game for him and I had to play along if I wanted to eat. I often had to climb on counters, cupboards, or even on top of the refrigerator. I eventually mastered this game and would not even bother asking questions: I'd just start searching, because it was faster than asking questions.

I always just thought my dad was amusing himself, like you would do with a pet monkey. Now that I look back I do see that searching for all those meals had some positive effects. For one, I can climb like a pet monkey. Also, Easter egg hunts were always easy for me because I had been finding my food a couple times a week for most of my life. Finding an Easter egg was no problem. Dinner, on the other hand, could be difficult.

My dad doesn't just take things away, though. He also loves to give gifts, the more unusual the better.

Almost every year he brings a present from nature to my grandmother on my mom's side of the family, a fairly conservative woman. For years she has politely smiled and accepted her piece of driftwood that my dad has dragged into her house, sometimes lugging this offering for miles. She has received bird nests, rocks, and driftwood. Lots of driftwood. He doesn't pay a dime for these presents, though sometimes they require a lot of sweat. Buying a present would be easier, but it wouldn't bring the complete satisfaction that he finds when he ceremoniously presents her with a dried up juniper stump.

My dad runs on this kind of creativity. He finds art, or at least something appealing, in almost everything nature has to offer, so he likes to gather, share, and collect the strangest things. My front porch is a display mantle that includes antlers, bones, mangled sticks, and the body parts from all sorts of carcasses. There might even be a piece of that porcupine in there.

Growing up, I remember being embarrassed to bring kids over to my house, with its peculiar porch and the yard decorations my father made from horse skulls and cow pelvises. My mom always said to tell my friends that my father was an artist and he was "expressing himself." This didn't seem like much of a solution at the time and the "art" on the porch just kept on growing, though my embarrassment didn't.

I eventually learned to appreciate much of the mangled and twisted debris that clutters my yard and porch. If I don't like one of my dad's new additions, I use the same approach that he uses when he sees bad art: I tell him it's "interesting."

Now, when friends or girlfriends see my front porch for the first time, I enjoy their reactions almost as much as my dad does. Last year, I was leading a girl to the door when suddenly she froze in her tracks.

"Myers," she said. "A foot just poked me."

Then I noticed the elk foot sticking out of the gatherings at the head of the handrail. I laughed and led her into the house, but I didn't have to say anything. She, along with my other friends, has learned what it means when elk toes nudge their ribs. "Oh, it's just Parks."

I admit now that I embarrassed too easily when I was younger, but who could blame me? I was young. My dad seeks personal satisfaction through odd behavior and he finds plenty of it. Look at the nicknames he has given me: one of the first was "Wiggler Squiggler." Not only did I have to answer to this nickname, my dad wrote songs about it.

Later, I became Barbecue Fuzzball, Sharkbait, Quagmolian and finally Quagamumba, a name I answer to today. All of these names engendered songs, which my dad still sings. Badly. They used to embarrass me a lot. Now I'm just amazed that a grown man can still delight himself so easily.

Still, these songs also taught me something about humility. After putting up with them all these years, I now know how to ignore the little things that embarrass most of my friends. My dad, though eccentric by any definition, is never embarrassed, almost always having fun, and rarely worries. He also helps me keep an open mind. Whether he's talking about something important, like bigotry, or something as simple as eating unfamiliar food, he has taught me to accept both things and people.

All my life, I've eaten every food that was offered to me—cold liver and fish eggs for breakfast is one example—and if I didn't like it my dad would repeat his usual explanation, "It's all mental." Then I'd eat it, act as if I enjoyed it, and tell myself to enjoy it the next time.

I hope this open-minded attitude about food has stretched beyond my dinner plate (once I find it) and I try to be receptive to everything that I confront in life.

My dad has also taught me, through his actions and misadventures, how not to behave in many situations.

He often likes to say "Do as I say, not as I do," then crawls out the passenger side window of a car traveling at highway speeds and climbs onto the roof, just to take a ride on top. Things like this frighten my mom, amaze me, and amuse his friends. But most of all, they thoroughly satisfy my dad.

He has always been a man who can make others smile and he can brighten any room, often accidentally. If he gives a speech to a large crowd, there's a fair chance his shirttail will be sticking out the fly of his pants. He has not just remained a kid at heart: he's a kid of the mind, the soul, and body. With this said, he knows how to fulfill his adult responsibilities. He just doesn't believe in the standards that modern society sets for adulthood, especially the ones he views as boring. He gladly takes on the major jobs while leaving the less "important" ones for others to worry about.

With all the laughs my father has given me, along with the tortures, I consider myself more than blessed to experience his serious side, the times when he has been my guiding force, my teacher, and my friend. His artistic talent and creativity speak for themselves. And he's lucky, too: he loves what he does for a living. Every night, he falls asleep knowing another day of contentment lies just around the corner.

A number of his adventures have led him to the hospital, and there are plenty of old crutches and splints around the house, along with an antique wheelchair he keeps in the basement, just in case. But he remains healthy and happy and doesn't believe that approaching fifty years old has had any effect on him at all. I will be moving away from home within a year for college and I'll take the memories of my father's lessons and good will with me.

In the dormitory, I won't have to worry about searching for my meals. But who knows? He might come to my room one day with a dead porcupine and some Quagamumba songs.

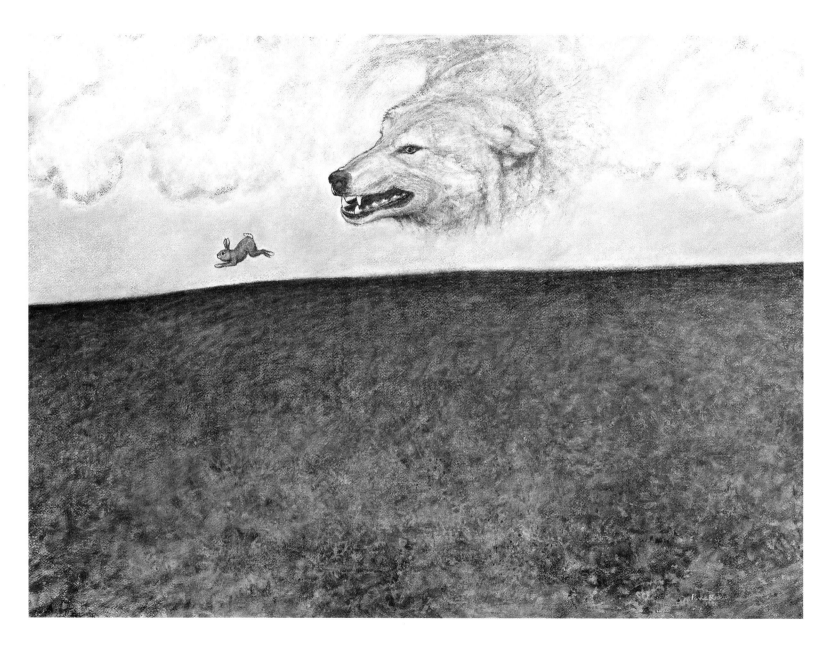

RUNAWAY IMAGINATION

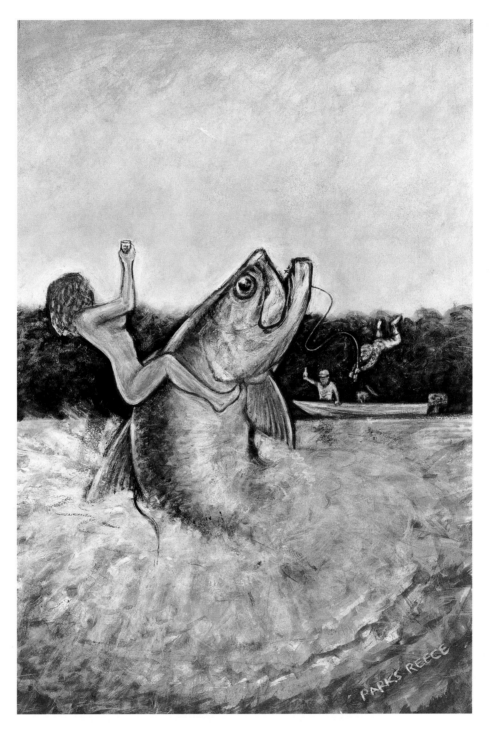

BIRTH OF VENUS II

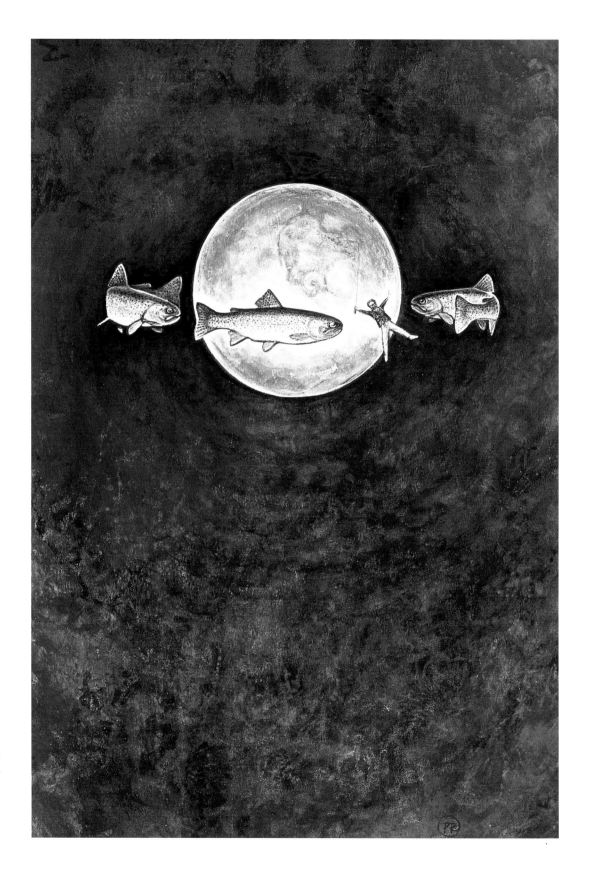

As the Whirl Turns

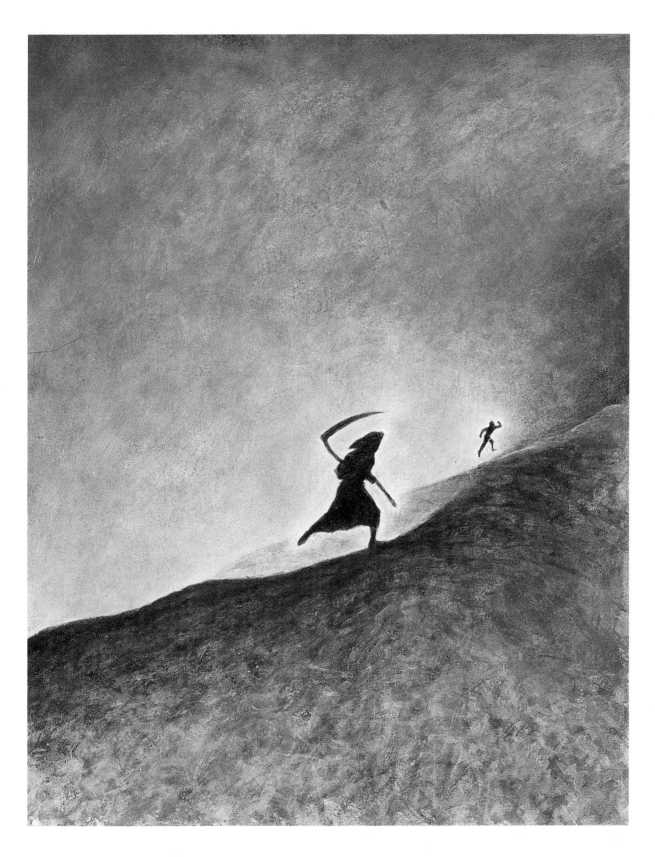

THE HUMAN RACE

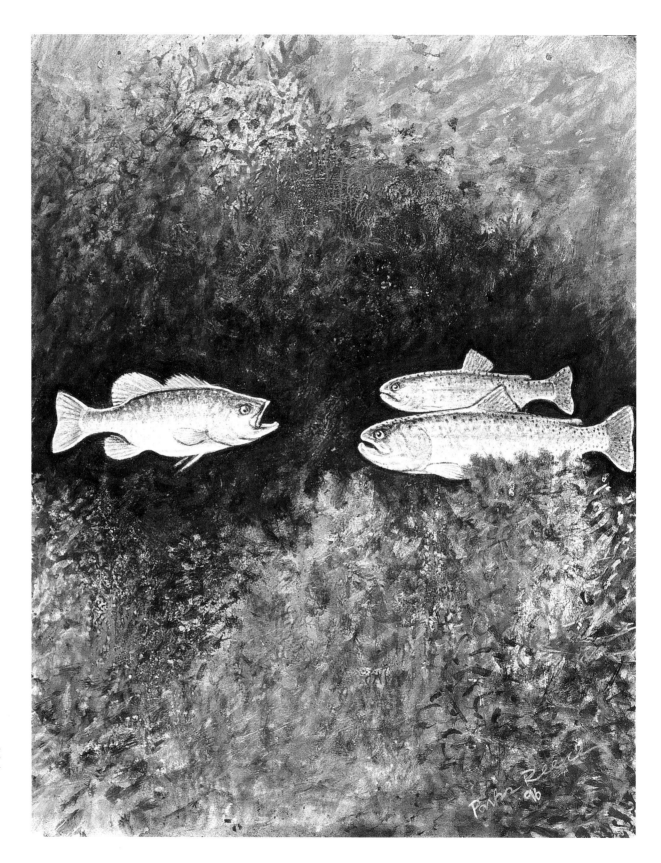

THE BASS HOLE

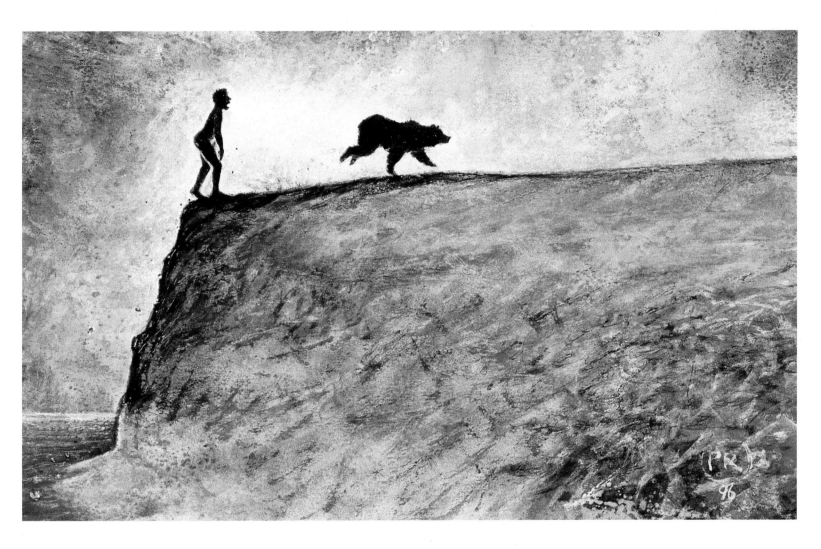

GARLIC EATERS LIVE LONGER

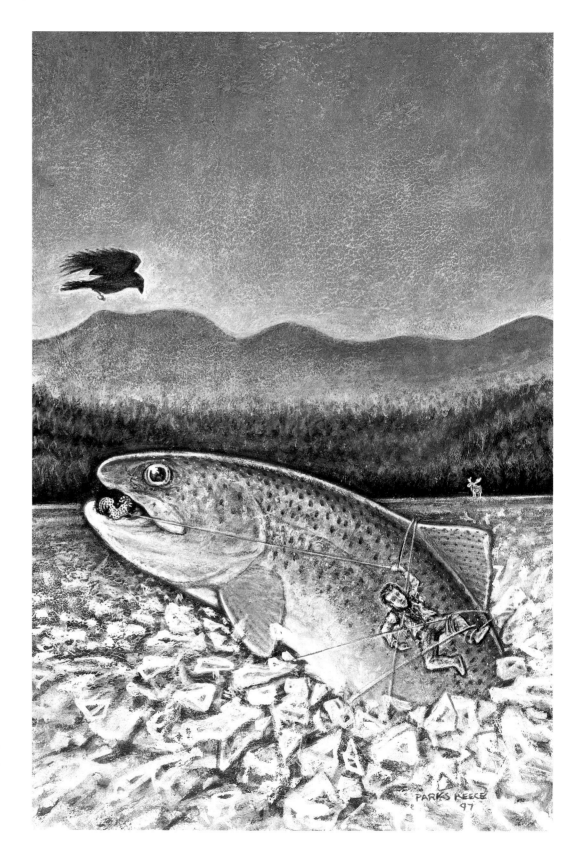

MOBY TROUT

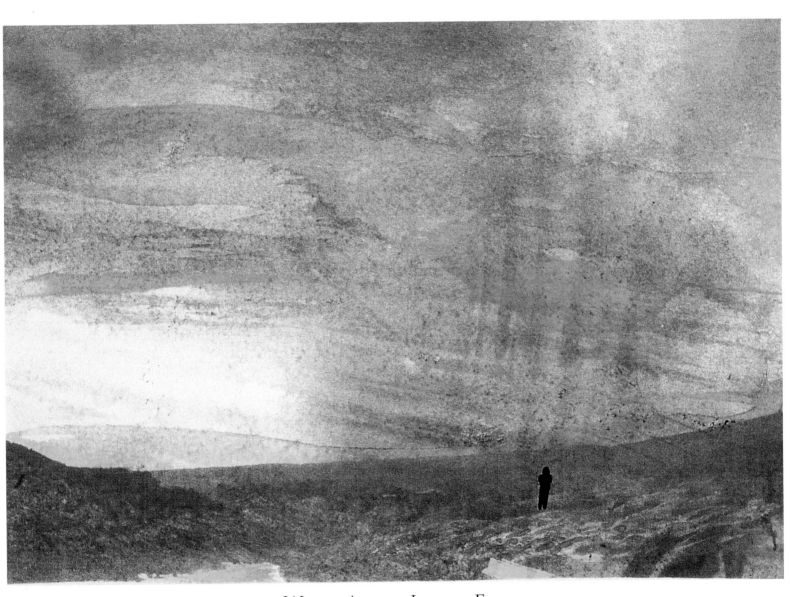

WHERE ANGELS LEER AT FRED

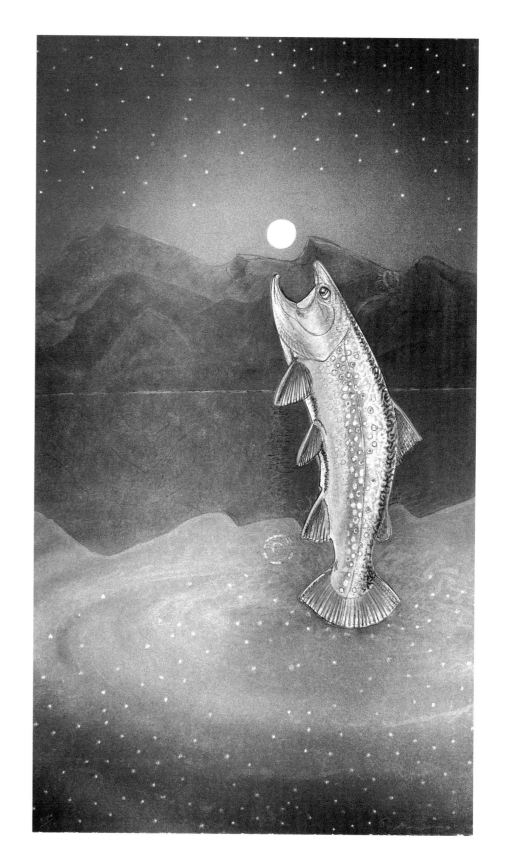

SHOOT FOR THE MOON

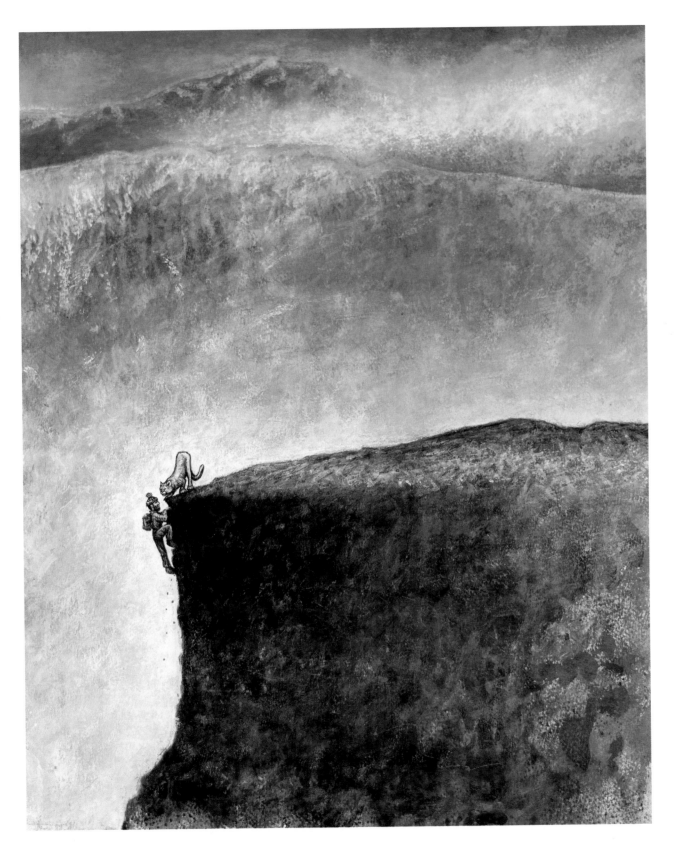

CAT WITH
BALL OF YARN

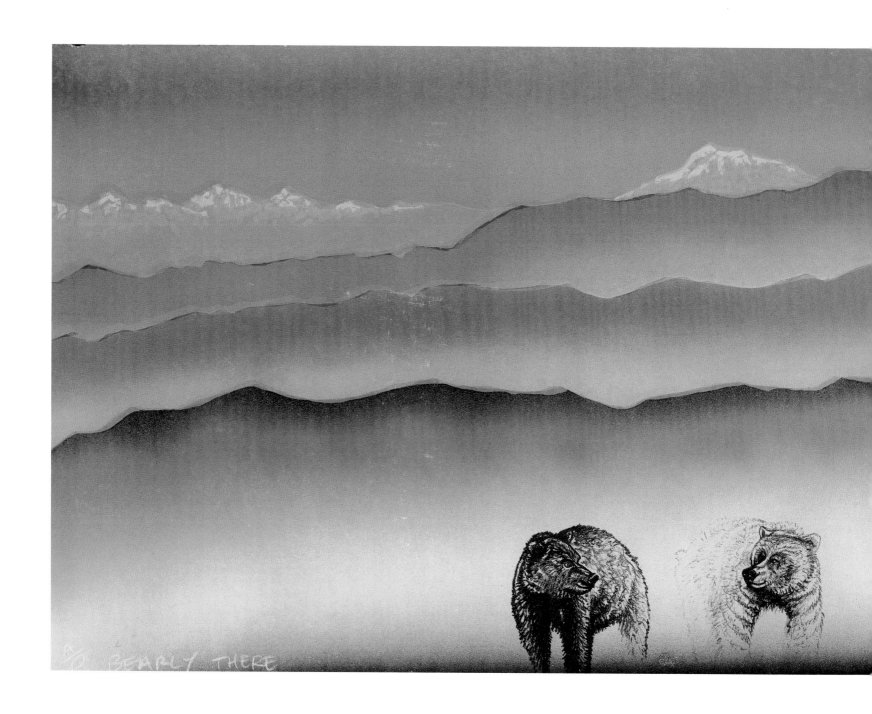

BEARLY THERE

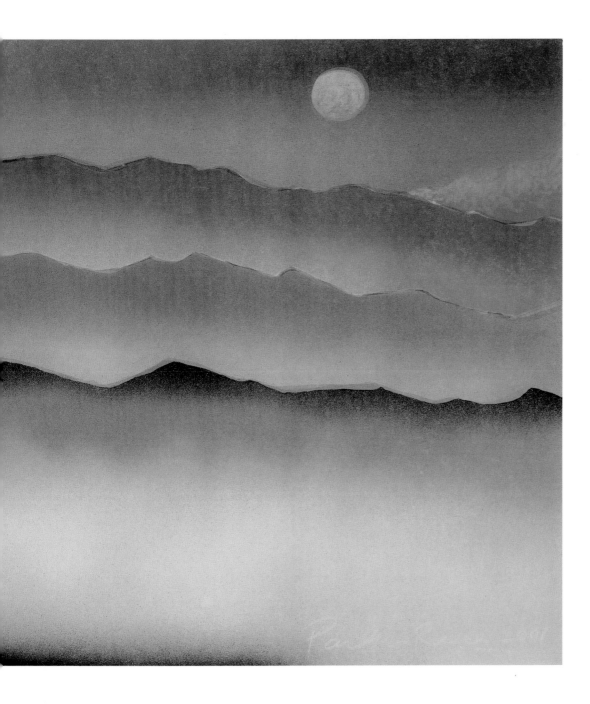

BEARLY THERE

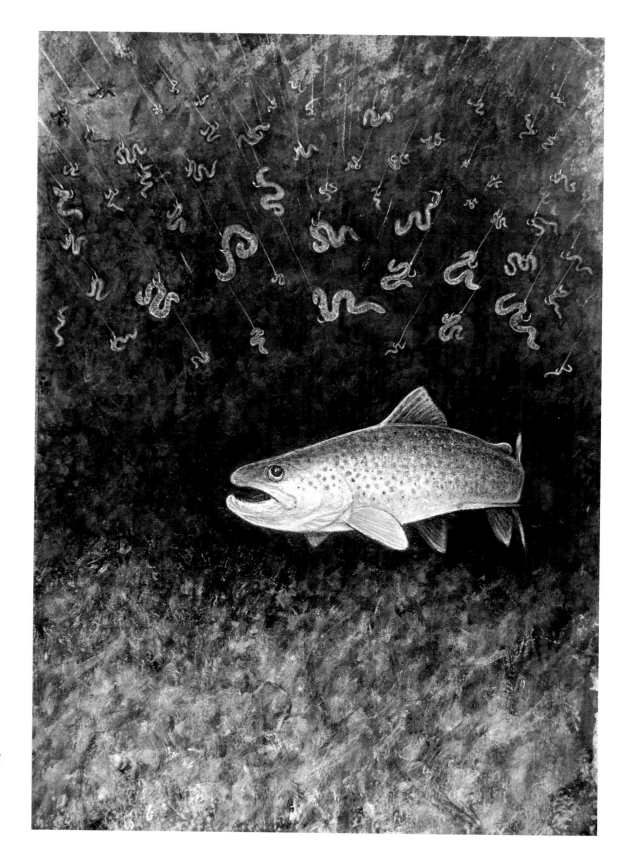

TROUT HELL

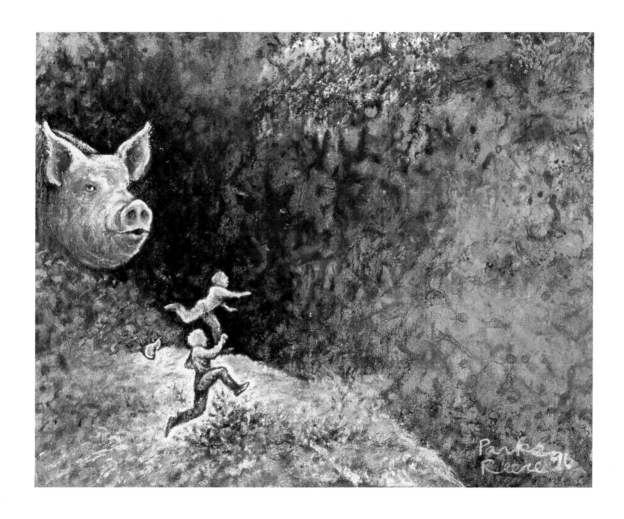

JURASSIC PORK

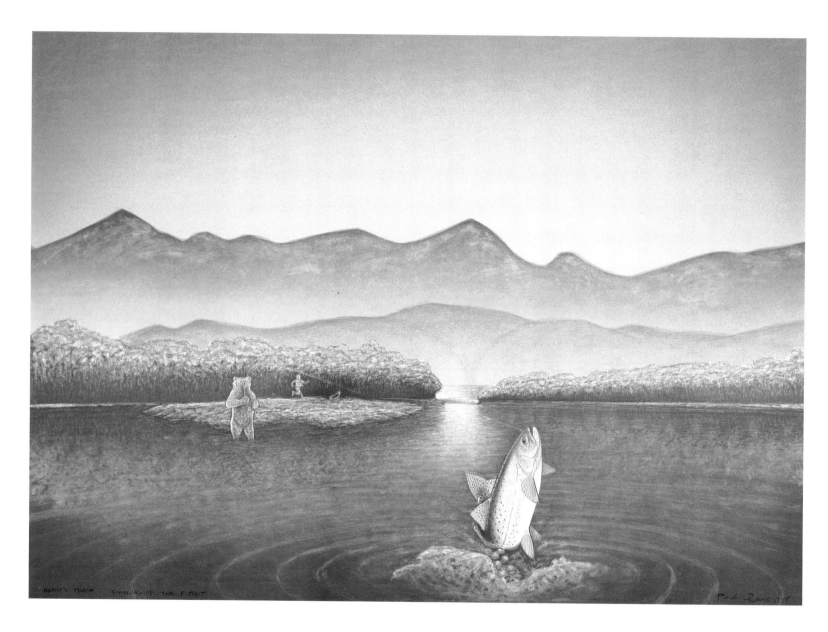

SURVIVAL OF THE FITTEST

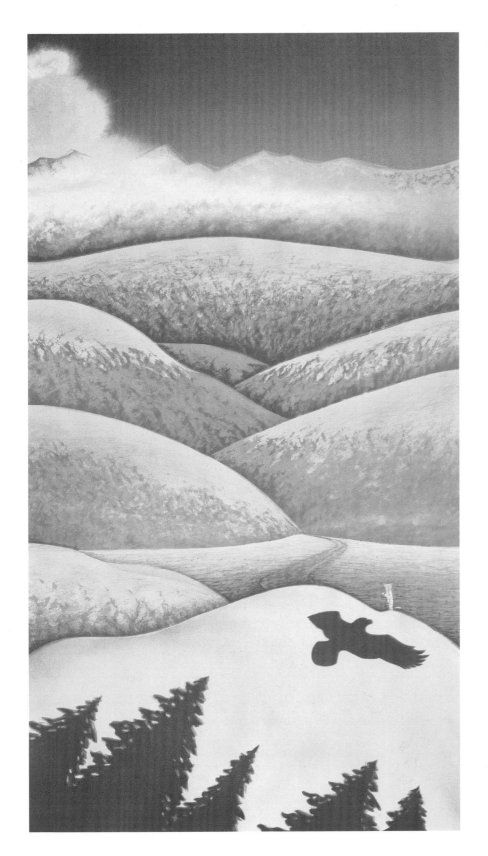

SHADOW BOXER'S LAMENT

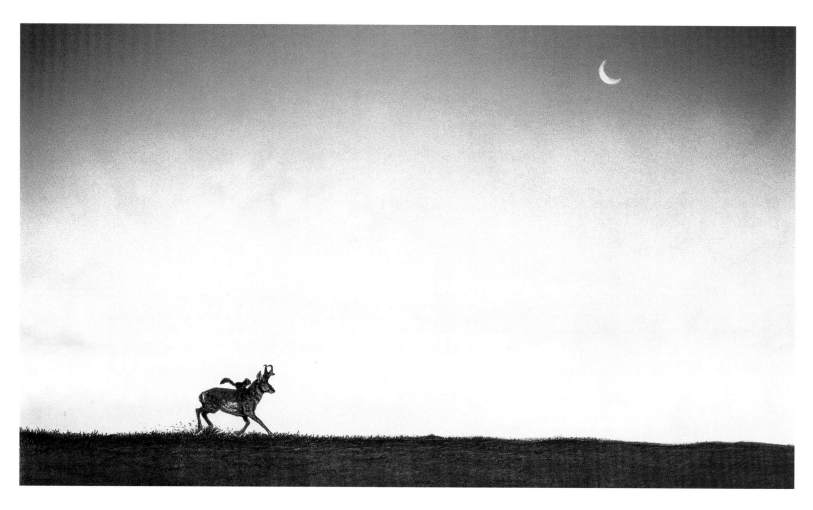

HIGH PLAINS HITCHHIKER

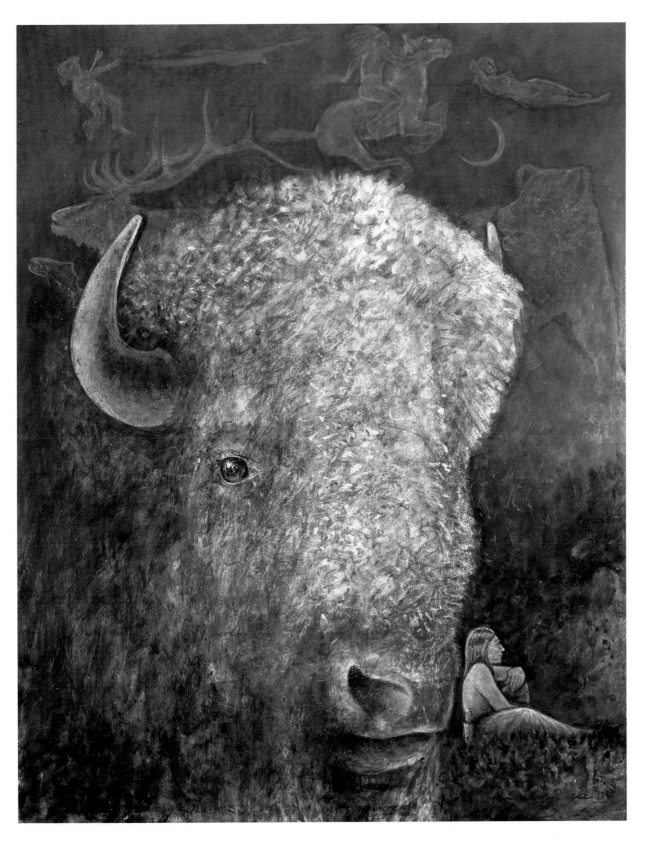

EARLY AMERICAN
DAYDREAMS

113

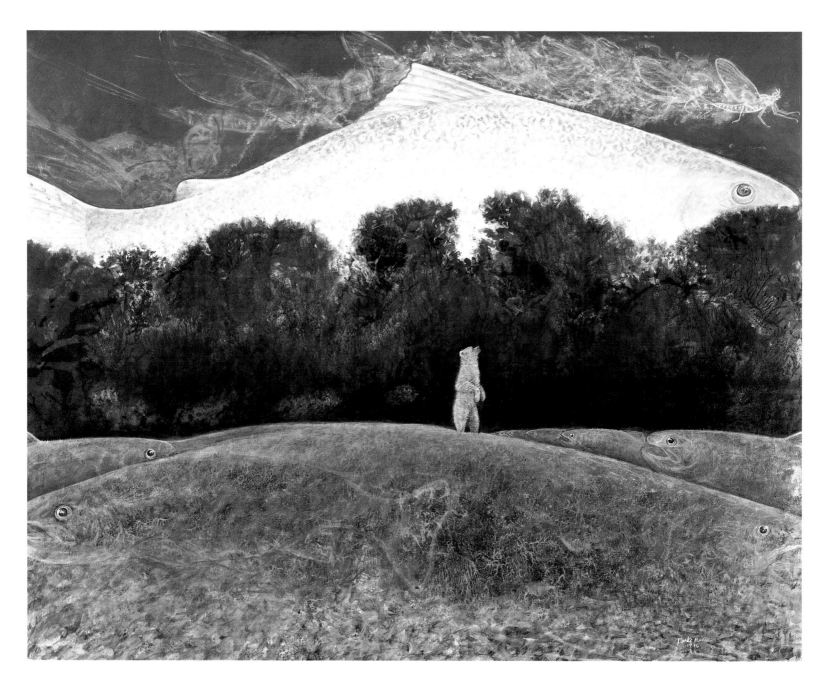

MYSTERIES OF LIFE

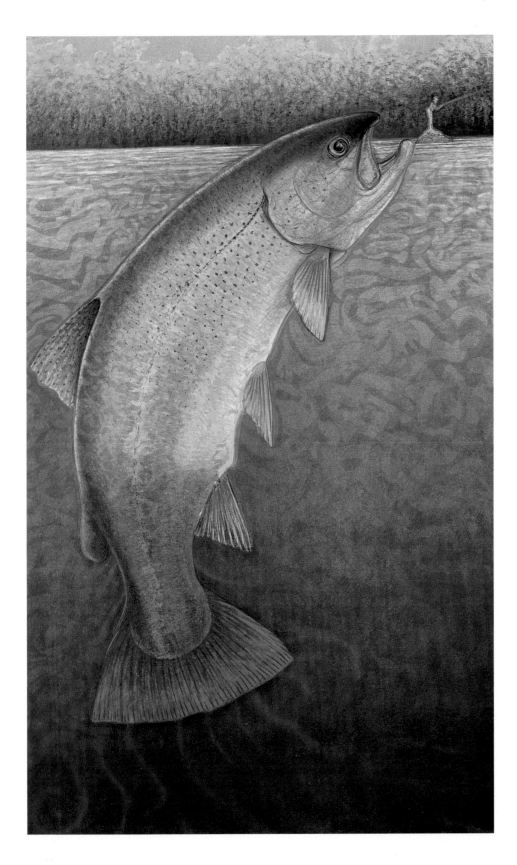

LIVE BAIT

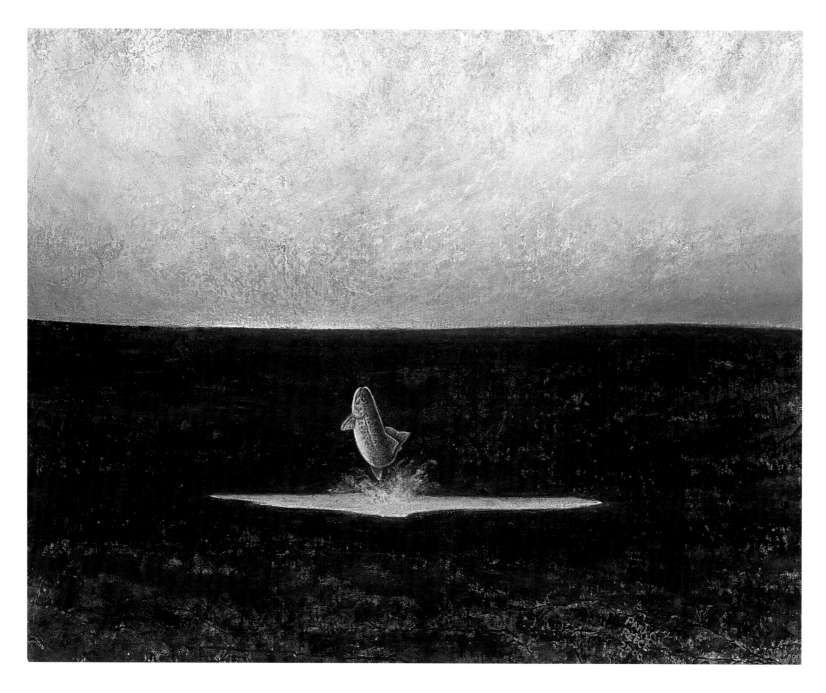

BIG WISH IN A SMALL POND

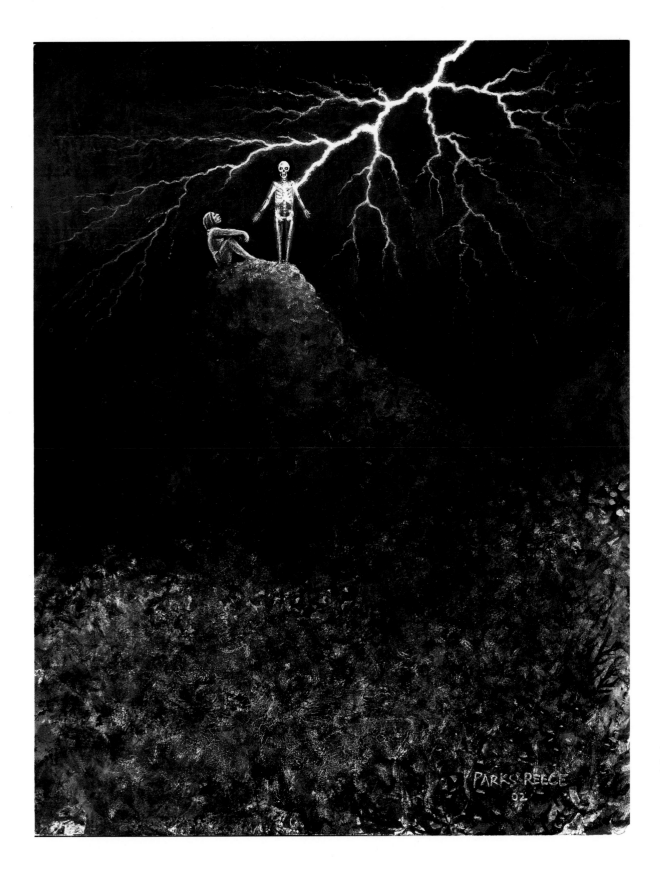

PALEOLITHIC X-RAY

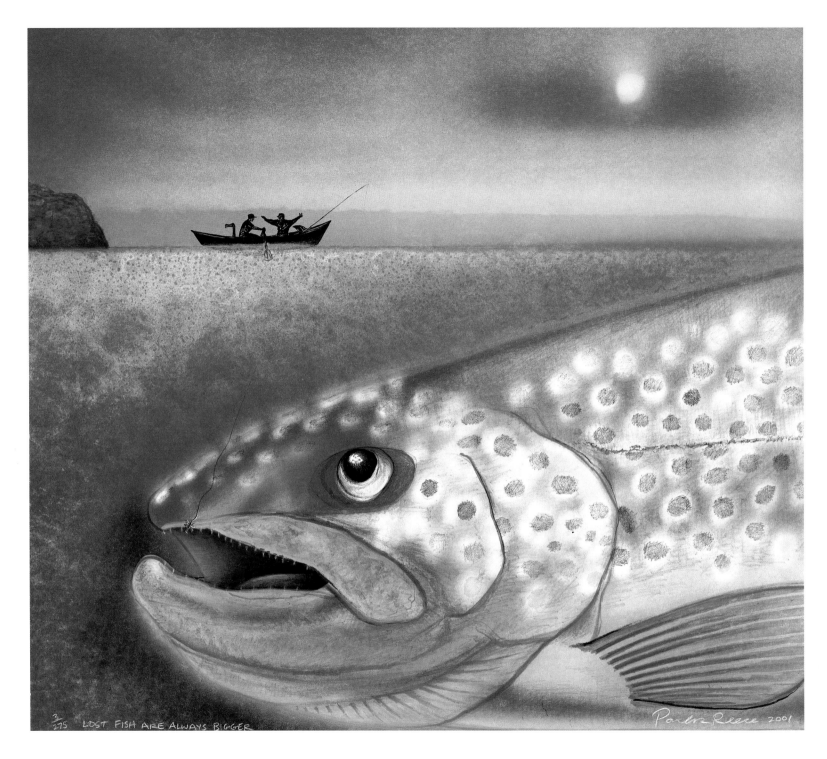

LOST FISH ARE ALWAYS BIGGER

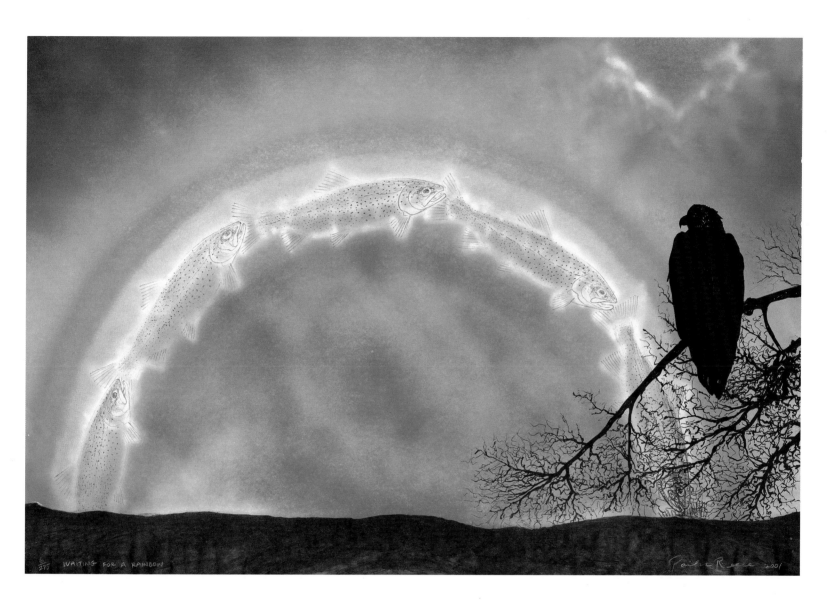

WAITING FOR A RAINBOW

An Elk Calls Home

by Greg Keeler

Hi Honey, it's me. No, no, don't worry, it's just August.
We don't have to worry about that for a month or two.
Yes, things are fine up here. When you're through
With the kids, hoof it on up and we'll mate, just
Don't get sidetracked by our neighbor, Buck. I trust
You even after that fling you had last year. Hey, you
Don't have to get testy about it. I told you how
I'd do anything to keep you happy. That's why I bust
My ass climbing around with my other cows
Looking for greener grass. It's for you, Dear.
Damn, I'm sorry, I didn't mean that. Lord knows
You're bigger and better built than one of those. Here,
Let me give you a little snort on the phone,
Just to show you how ... Honey? (Clunk, dial tone.)

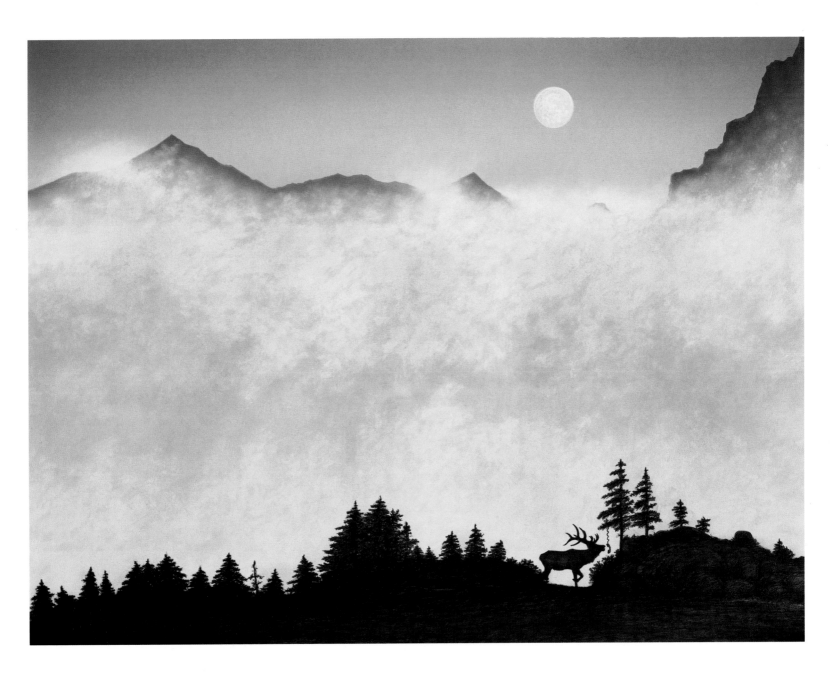

CALL OF THE WILD

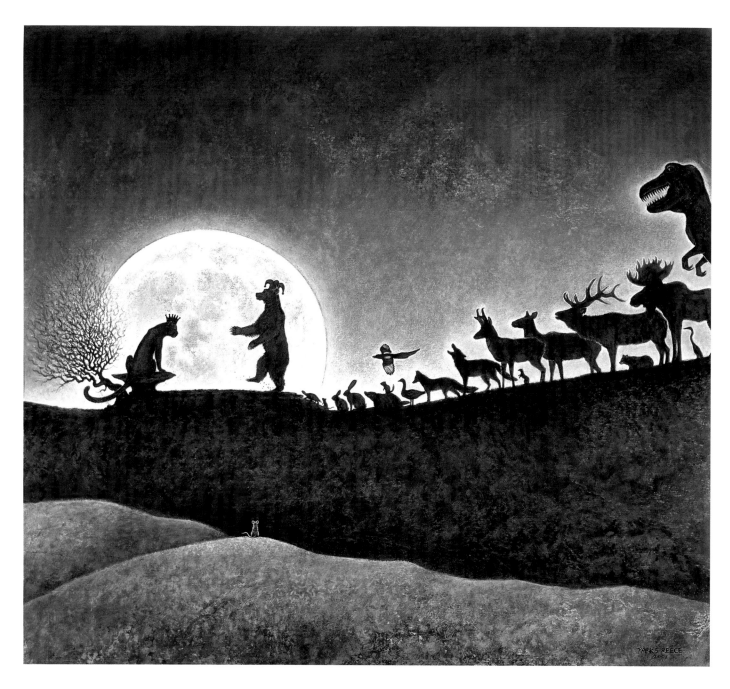

EVERYBODY LOVES SHAKESPEARE

Call of the Wild Art Specifications

Sizes are height by width, in inches